# THE
## *Archive Photographs*
### SERIES
# FARNWORTH

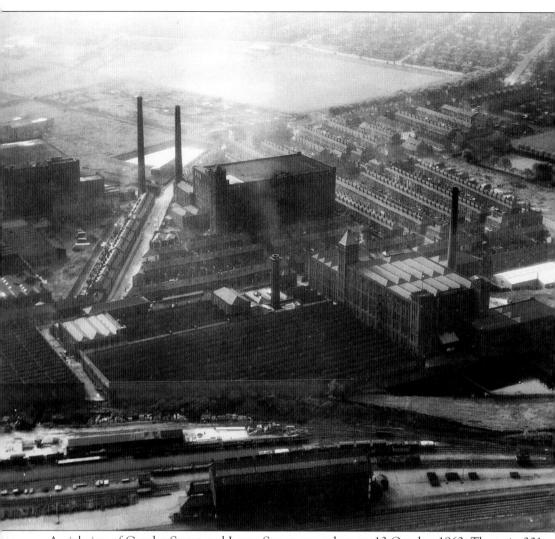

Aerial view of Cawdor Street and Lorne Street area taken on 13 October 1962. The twin 201 feet high chimneys of the Bolton Textile Company's No. 1 and 2 mills had been familiar landmarks since the turn of the century. Just before the First World War there were 46 mills operating within $2\frac{1}{2}$ square miles. In 1957 6,659 people or 18% of the population were employed in cotton. One chimney was to be lowered in 1970 and the other was to be completely demolished. The No. 1 mill had been unused for some time and plans were in hand for demolition of the upper floors as well as filling in the mill lodge to provide parking. The familiar twin chimneys symbolising the way in which Farnworth had earned its living for so long were destined to disappear within the next few years. (Ref. No. A107416. Reproduced by kind permission of Hunting Aerofilms, Gate Studios, Station Road, Borehamwood, Herts. WD6 1EJ)

THE
*Archive Photographs*
SERIES

# FARNWORTH

*Compiled by*
Ken Beevers

**TEMPUS**

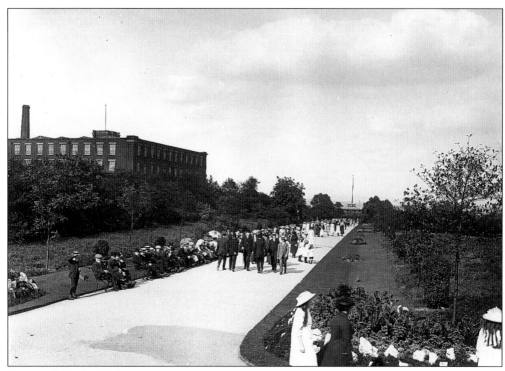

Farnworth Park, 1914.

*Dedicated to Farnworthians everywhere*

First published 1997
Reprinted 2004

Tempus Publishing Limited
The Mill, Brimscombe Port,
Stroud, Gloucestershire, GL5 2QG
www.tempus-publishing.com

British Library Cataloguing in Publication Data.
A catalogue record for this book is available from the British Library.

ISBN 0 7524 0724 4

Typesetting and origination by Tempus Publishing Limited.
Printed in Great Britain.

# Contents

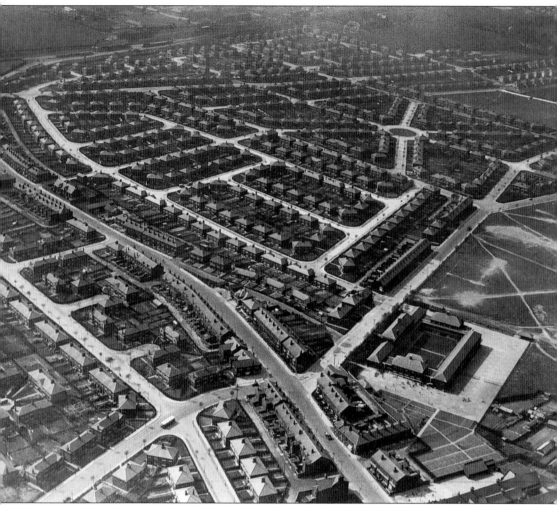

Aerial view of Plodder Lane and Harper Green, 1961.

# Acknowledgements

This book would not have been possible without the policy to acquire and conserve photographs by the Library Service. Many of these photographs have been acquired over the years, many have been donated and copyright has been ascertained where possible and due acknowledgement made. Bolton Libraries would welcome the opportunity to increase their photograph collection of the area. Photographs loaned to us can be copied quickly and returned to their owners.

I would like to thank colleagues at Farnworth Library, Bolton Archives and Local Studies Library, Bolton Museum, Christine Bell of the *Bolton Evening News* Library, and members of the Farnworth and District Local History Society. Also Hunting Aerofilms and the *Bolton Evening News* for permission to reproduce photographs. Also Gavin and Jacqui for help with typing.

# Introduction

The name Farnworth, meaning the 'place among the ferns', first appeared on land survey records 800 years ago. Today probably the only ferns to be seen are growing in the park, although there are ferns to be seen in the old Borough coat of arms which was in use until 1974. Farnworth, now part of Bolton, has always been an ordinary industrial town covering an area of only three square miles but it has a history and character to be proud of.

From 1860 until 1975 the town had its own newspaper, the *Farnworth Observer*, which became the weekly *Farnworth Journal* in 1873 and this is a rich source of information on the history and everyday life of the community. During this century there were three managers of the *Journal*, J.W. Pickford, Ralph Brownlow and Harry Bromley who all worked for the paper for fifty years. They made an enormous contribution to the recording of both the momentous and the minute details of Farnworth life; as well as being fully involved in the town, all three can also be found in this book. Mr Pickford was a campaigning journalist who advocated many social improvements which later took place. He was also, in his early days, an enthusiastic amateur photographer and was a familiar figure in the district with his half-plate stand camera. Many of these photographs he made into stereographs, being one of the pioneers who adopted the small size, flat film cameras which made pictures just large enough for the preparation of lantern slides. He took many photographs of Farnworth which he presented to the library on his retirement in 1929 and many of these are included here. Most were taken in the period 1890-1910 and record significant events such as celebrations for Queen Victoria's Diamond Jubilee in 1897 and the people and places of the time. As a result of his foresight and skill we have these photographs as a permanent record. These are supplemented by other photographs from the Farnworth Library collection, from unknown photographers, from the pages of *The Journal*, images on postcards and some by kind permission of the *Bolton Evening News*. This book is a glimpse of Farnworth's recent history based on the photographs that became available.

Farnworth's industrial history dates from the last decade of the seventeenth century with the building of a paper mill by the Cromptons of Great Lever. Under the control of Thomas Bonsor Crompton, born in 1792, the annual output reached almost 1 million tons. Acknowledged, with James Rothwell Barnes, as one of the founders of Farnworth he employed 800 people at the time of his death. His contemporary James Rothwell Barnes was a cotton manufacturer who built Farnworth's first steam weaving mill and in 1832 introduced cotton spinning. His son continued the family business and developed it further, to the extent that the Barnes family were linked with the growth of Farnworth in many ways and the name occurs in several contexts. The effect of industrial development was that the population grew rapidly from 1,439 in 1801 to 28,131 in 1911. Like many other Lancashire towns Farnworth suffered heavy unemployment during the trade depression of the 1930s, and after the Second World War cotton manufacture, and its associated trades, ceased to be the principal sources of employment. There are few links with the pre-industrial history now but there still remains Rock Hall and although mansions such as Darley Hall, Birch Hall and Birch House have long gone, photographs have survived. Farnworth has had many benefactors, particularly among its one

time industrial leaders, the Barnes', the Prestwich's, the Topp's, to name a few and there are plenty of reasons to remember them, for example, the Park which was the gift of Thomas Barnes.

In 1939 Farnworth became a Municipal Borough. This was a proud moment for the town although its achievements before then were many. A town that grew up as Farnworth did with industry rather than beauty as its driving force was bound to have its problems in terms of health, housing and living conditions It had, though, a splendid record in municipal house building and public health. In 1930 it was the first town in the country to take action in slum clearance under the Housing Act of 1930 followed by an extensive programme of house building. It was also one of the first towns in the country to provide nursery education and a town whose priorities were the health and well being of its citizens.

The fact that it had a tremendous record in improving these, and rising above them, was due to the people. There are many examples in these pages of people who devoted their lives to the town, such as Dr Clarke, Dr Lucas, the Entwisle family and many others. One such Farnworthian was Harry Bromley, a man who cared about Farnworth, who worked tirelessly for its many organisations and was, until his death, Chairman of the Farnworth and District Local History Society. The society still meets at Farnworth Library and new members are always welcome.

Working for the library service and based at Farnworth for several years I found at first hand that Farnworth people have many qualities and although there are many things that contribute to the historical significance of the town, it is the people who matter most. Farnworth people can justly be proud of their past and their contribution to it.

Ken Beevers
April 1997

Arms of Farnworth Urban District Council, 1894-1939.

# One
# Civic Pride:
## The Place Among The Ferns

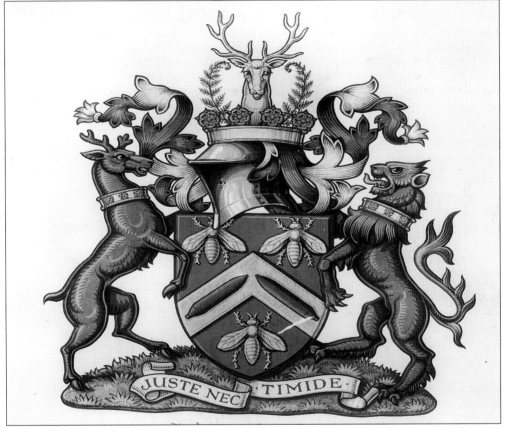

Farnworth was governed by a Local Board from 1863 until 1894 when it was replaced by the Urban District Council. In 1939 the town became a Borough and a new coat of arms was adopted, symbolising the nature, history and character of the town and the pride in its achievements. The shield indicates the industries of the Borough; paper making and cotton spinning, hornets being considered nature's paper makers. The stag's head is the crest of the Hulton family and was incorporated in the arms used by the Urban District Council. The branches of ferns refer to the meaning of the name Farnworth - 'the place among the ferns'. The motto of Farnworth, 'juste nec timide' means ' be just and fear not'.

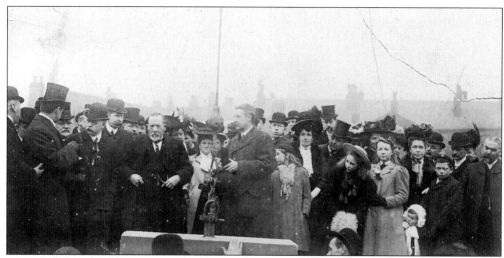

The laying of the foundation stone for Farnworth Town Hall, 18 March 1908. The stone bore a large inscribed bronze plate and under it a bottle containing local newspapers and the Council's year book was placed in a cavity. The Council asked Mr T. Ivers JP, a past Chairman of the Council, to lay down the stone. In his speech he made reference to the fact that for 43 years they had carried on the affairs of Farnworth in a room about 14 feet by 30 feet in which 22 gentlemen had to meet every month. These were premises rented in Darley Street.

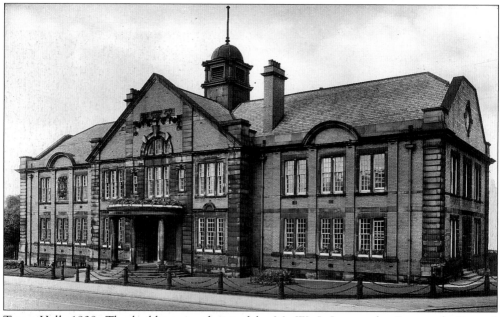

Town Hall, 1939. The building was designed by Mr W. J. Lomax the Farnworth Council Engineer, the builder was T.E. Coope and the cost was £10,000. As well as housing all the Council offices, except for education, it also contained the Council chamber, committee rooms, Mayor's Parlour, etc. The Council chamber was recently converted to a room for community use and a staircase and lift added on the Trafford Street side with a new opening, incorporating a memorial window from Farnworth Grammar School. At the stonelaying, concern was expressed that there was no assembly room in the building but this omission has now been made good. The railings were later removed for the war effort.

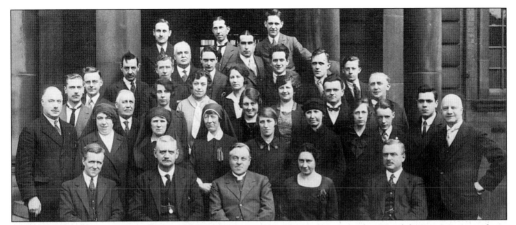

Town Hall staff in 1928 on the occasion of Miss A. Smith leaving the Health Department for a permanent position on the staff of The League of Nations at Geneva. From the top, left to right; J.Y. Stones, H. Cunliffe, N. Doodson, J. Crossley, F. Entwistle, J. Marshall, M. Holliday, T.E. Corscaden, S. Beck, J. Bloor, J.H. Bennett.
F. Ashton (Surveyor), J. Short, L. Holland, Mrs N. Martin, Miss O. Rees, Miss G.M. Robey, Mrs N. Short, H.J. Ogden, E.J. Barlow. A.J. Hutchinson ( Electrical Engineer), Mrs F. Cunliffe, Miss C.I. Grant, Miss A. Pendlebury, Miss E. Taylor, Miss P. Rowlands, Miss M. Aspden, Miss H. Stones, A. Cunliffe, J. Birch, S. Seel.
H.J. Tyrer (Director of Education), W. Tyldsley (Clerk), Revd J. Wilcockson, Miss A. Smith, Dr A. G. Glass (Medical Officer). ( *Farnworth Journal* )

The Revd John Wilcockson, the Charter Mayor, in 1939. He was the vicar of St Thomas' from 1915 to 1943 but it was his dynamic personality and political career that made him a household name in Farnworth and District for almost 30 years. He became involved in politics because of his belief that it was a parson's job to look after the welfare of his flock in all aspects, not just spiritually. He was first nominated as a Labour candidate in 1919 and soon demonstrated he was a man of action as well as words. Housing and health were his main concerns and he chaired both committees. It was due to his initiative that Farnworth became the first local authority in the country to clear slums under the 1930 Housing Act and embark on large new housing developments. He was unanimously elected as Charter Mayor by his colleagues who in so doing made history for Farnworth as he was the first Church of England clergyman in the country to be Mayor of a Borough. He retired to Worthing in 1943 feeling he could achieve no more and died in 1969 aged 97. His remains are buried in Farnworth Cemetery.

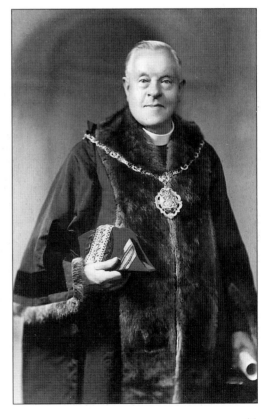

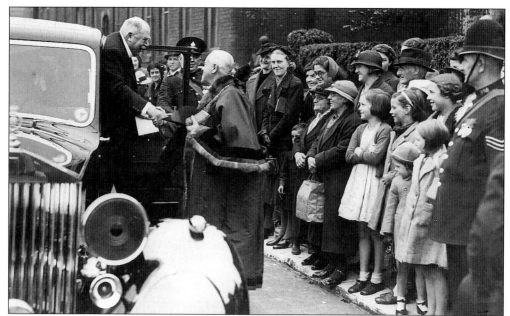

The beginning of an important epoch in the municipal life of the town began on 30 September 1939 when Farnworth was granted Borough status by King George VI and received it's Charter of Incorporation from Lord Derby. He is seen here meeting the reception committee, led by Revd Wilcockson at the Farnworth boundary. The granting of the Charter was a matter of great civic pride since it was a recognition of its efficiency and official standing as well as being essential to the continued development of the town.

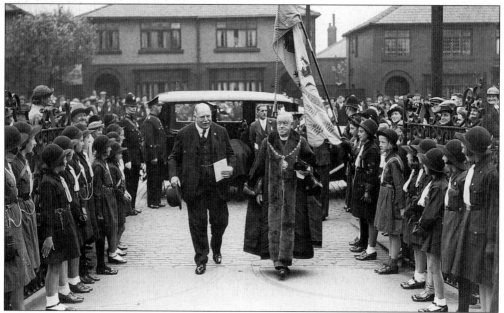

From the boundary the party travelled to Farnworth Park via Worsley Road, Albert Road, Egerton Street, Moses Gate and Bolton Road. Here Lord Derby laid a wreath at the Cenotaph as well as inspecting and talking to various representatives of the town including girl guides, scouts and other uniformed groups.

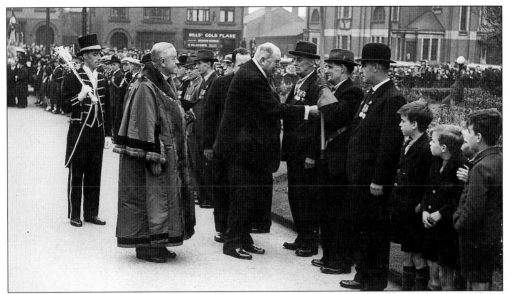

Lord Derby was the Lord Lieutenant of Lancashire and he and the Charter Mayor are seen inspecting the Farnworth branch of the British Legion. The Baptist Church is in the background and opposite the shop that was on the corner of Carlton Street. The ceremony took place later in the Co-operative Hall which was decorated for the occasion. The Charter is kept in the Archives at Bolton. The mace bearer was Mr J. Morris.

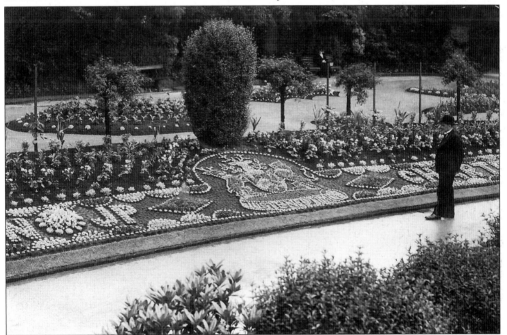

The Park Superintendent admires the floral tribute in the park to the Charter Mayor and the new coat of arms, in July 1939. The *Farnworth Journal* captioned this, 'Charter Bed - Farnworth says it with flowers' and went on, ' it is a custom when someone has a specially pleasing message for someone else, to say it with flowers and therefore it is fitting that Farnworth should inform its citizens of its ascent to a higher status with flowers also'.

There were civic processions outside the Town Hall involving all the services and an important group, in view of the recent outbreak of war, were the Air Raid Wardens. At the front of the procession, second from the right, is Harry Bromley, manager of the *Farnworth Journal* from 1962 to 1973 and on the staff for 50 years. He dedicated his working life to serving Farnworth and in addition worked tirelessly on behalf of many local organisations and societies. (*Farnworth Journal*)

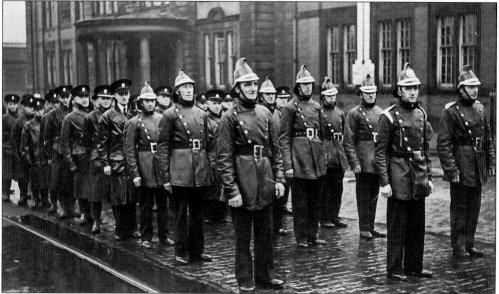

The Fire Service on parade. Many other festivities and celebrations for Charter Day and beyond had been planned by a committee which had been meeting for several months but the outbreak of The Second World War on 3rd September meant that all of these were cancelled. (*Farnworth Journal*)

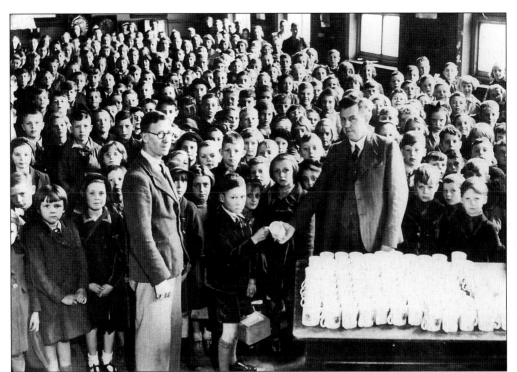

One of the celebrations that was retained was the presentation of souvenir mugs to children in local schools and some of them are pictured here at the Queen Street Council School. The child receiving his mug is carrying his gas mask. Making the presentation is Councillor W. McManus, Chairman of Farnworth Education Committee. Also in the picture is the head teacher, Mr E.E. Jones. In addition local pensioners were each presented with a voucher worth 1 shilling and six pence. (*Farnworth Journal*)

Farnworth and Kearsley people responded enthusiastically to the war effort by making sacrifices to raise money. Salute The Soldier Week took place in 1944 when the town were asked to raise £240,000 by saving and investing money in National Savings Certificates or Bonds during this week. It followed War Weapons Week when £303,735 was raised in savings and HMS Holcombe, a destroyer, was purchased but was lost in action. The Wings For Victory Appeal raised £260,227. In every case these appeals were well above target.

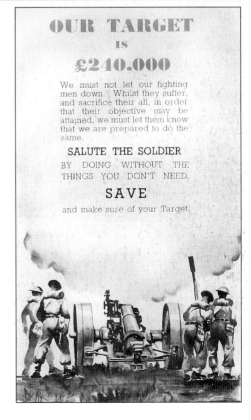

OUR TARGET
IS
£240.000

We must not let our fighting men down. Whilst they suffer, and sacrifice their all, in order that their objective may be attained, we must let them know that we are prepared to do the same.

**SALUTE THE SOLDIER**
BY DOING WITHOUT THE THINGS YOU DON'T NEED.

**SAVE**
and make sure of your Target.

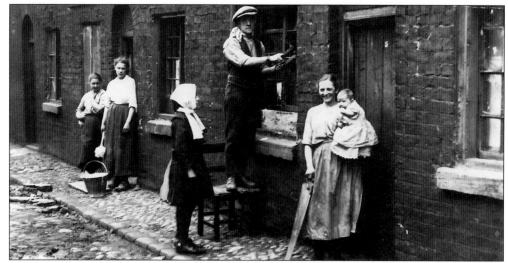

Housing in Farnworth 1930. Farnworth Council was probably the first authority in the country to complete proposals for dealing with slum property under the Housing Act which came into force 16 August 1930. By September, clearance and compulsory purchase orders were approved for two areas of New Bury, Welsby Square and Tonge Street. The Revd Wilcockson said, 'We are at the beginning of a new era. If I had my way I would like to see every house in which a bath could not be placed demolished'. By 1934, thirty areas of undesirable property had crumbled beneath the weight of the demolition order, 231 houses had been cleared and 151 more were due to be demolished. From then on a programme of house building was carried out culminating in three main areas of housing, in Harper Green, Highfield and New Bury.

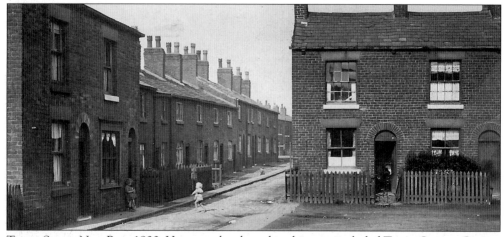

Tonge Street, New Bury 1930. Houses to be cleared in this area included Tonge Square, Gorton Row, Greenhalgh Terrace and Albert Place. The area was deemed unhealthy, the houses lacking light, air, ventilation and proper conveniences. Tonge Street comprised eight houses, each consisting of a living room, a scullery 6ft by 9ft, and two bedrooms. They were without yards and the backdoors opened on to a paved passage only 8ft wide on to which the backs of four houses on Tonge Square also opened. The houses were damp and had no food storage accommodation. There were only five water closets, 80 feet away from the front of the house and they were not screened from the highway. In December 1930 the *Farnworth Journal* reported that the Council would be building 1,300 new homes in the next five years. (*Farnworth Journal*)

**Farnworth Urban District Council.**

# SUMMER DIARRHŒA

To the Mistress of this House:

Will you help to improve the health of our town, and prevent the terrible results from Epidemic Diarrhœa among our infants by carrying out the following suggestions :—

Keep your house very clean.

Open windows daily, particularly in the bedrooms; top and bottom when room not in use, and top at **all times.** Fireplaces should not be blocked up.

In hot weather burn all bones, stale vegetables, over-ripe fruit, and other rubbish, do not put them in ashpit or leave them in living room as they encourage flies.  Flies poison food and carry diseases.

Slops should not be emptied into ashpit but down grid in back yard.

Keep yard clean and dry and do not let children play near ashpit.

Ashpits must be kept dry. Once a day when doing fireplace scatter a shovelful dry ashes down closet (not if a water closet.)

Flush sinks and gullies **daily.**

All bad smells should be inquired into **at once,** if unable to trace cause, report to Nuisance inspector at Town Hall.

The Council supply disinfectants where required **FREE,** if called for at Fire Station.

**Summer Diarrhœa in infants** is very fatal and can be prevented by proper regular feeding cleanliness and

**Buy the milk twice a day**—not once only, **boil it at once** for two or three minutes, then place it in a **clean jug** with a cloth over the top, and stand the jug in a basin of cold water to keep milk cool.  The **milk must be covered over** to keep flies from it.  One or two tablespoonfuls of **lime-water should be added to each feed.** Do not put teat of bottle into your own mouth.

**Do not give baby sour milk.**

Do not keep any milk left in bottle for infant's next meal—it upsets babies.

The **bottle must be boat shaped** with teat to turn inside out, but no **rubber tube.** Scald bottle with hot water after every meal, also teat, and leave both standing in cold water till needed.  **Good milk is often spoiled by dirty bottles.**

If milk has turned sour and you cannot get more, use **best** sweetened condensed milk for one or two meals.  Get small tins and cover opened tins with muslin and keep them cool.

**Early treatment necessary.**  In any case of sudden diarrhœa or vomiting, stop milk at once, give only cold water that has been boiled, or thin barley water (see below how to make barley water), **and send for doctor immediately.**  Do not think diarrhœa will pass off without treatment, baby may be so ill in a few hours that no treatment will be of any use.

**Baby will not starve** for a few days if only plain water or barley water is given.

Do not think that when baby cries or is sick that it needs more food.

Infants may die in 24 hours from the starting of summer diarrhœa if neglected.

## HOW TO MAKE BARLEY WATER.

Take three teaspoonfuls of pearl barley, wash it well, put on it some cold water and place it on the fire till it boils, throw this water with the scum away, add to the pearls two pints of fresh cold water, boil it half or three-quarters-of-an-hour, strain it off into clean jug and cover with clean cloth.

**Make Barley Water fresh twice a day.**

Information leaflet 1912.

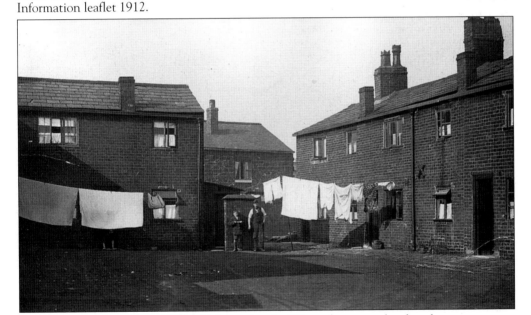

Welsby Square, New Bury 1930, which consisted of fifteen houses, a slaughter house, a manure pit and a cattle lairage shed. The Revd Wilcockson said, 'some of the homes are not fit for habitation, indeed some were simply holes for people to creep into'. One resident of Barton Road said he'd lived there for forty two years and he'd brought up a family of nine including some six footers, so that didn't speak so badly for the property did it? It was the healthiest little spot in Farnworth with sunshine, morning, noon and night. He didn't want to leave until he was carried out. (*Farnworth Journal*)

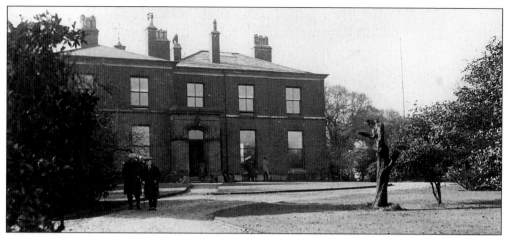

Greenbank House, November 1929, located between Glynne Street and Trentham Street. Greenbank was the home for several generations of the Barnes family and was given to the town for use as a nursery school by Harold Barnes, great grandson of Thomas Barnes. Mr and Mrs Barnes lived at the Quinta, Chirk, Salop. The site covered two acres, with woodlands and ornamental gardens, and three reservoirs. The house had several rooms, cellars, a library, coach house, stables and eight bedrooms. The house was converted into a nursery school with provision for about 120 children and an ante natal clinic was also established in the upstairs rooms with a separate entrance. The school ceased in 1937 as not enough children were making use of it and a new one was to be built. It was acquired by the firm of C.W. Norris, Timber Merchants.

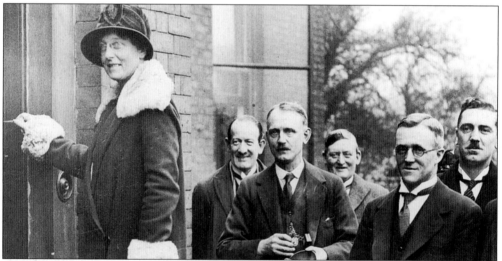

This was a red letter day in the history of Farnworth education, 10 April 1930. Lady Trevelyan, the wife of the President of the Board of Trade officially opened Greenbank Nursery School and ante-natal clinic. At the time there were only twenty nine nursery schools in England, Scotland and Wales and this was the first, not just in Farnworth, but in the whole district. George Tomlinson, was Chairman of the Education Committee and he was praised by all parties for the part he played in getting the school established. The aim was to relieve those mothers who went out to work and to tempt into healthy surroundings children from poorer homes so that they should have early medical attention, social training, a good mid-day meal and a liking for school and school life. (*Farnworth Journal*)

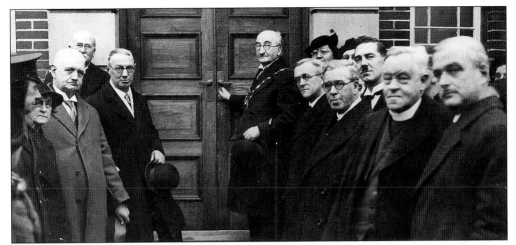

The new School Clinic and Health Centre was opened on Wednesday 12 January 1938 at a cost of £5,150. Here we see Councillor S. Taylor JP opening the door. Nearest left is Councillor A. Jones and nearest right is Dr A. Glass, Medical Officer of Health. Speaking at the opening of the necessity for a new clinic Cllr Taylor said that in 1904 in Farnworth the infantile death rate was 262 per 1,000. With more interest taken in maternity and child welfare the death rate was now 63 per 1,000 and the new clinic would help reduce that even more. The *Farnworth Journal* also carried a New Year message to the children of Farnworth from Dr Glass, 'One of the great enemies to a healthy body is DIRT. So boys and girls will you begin this New Year with the resolution that you will keep your bodies clean, with this slogan - Where there's dirt there's danger.' (*Farnworth Journal*)

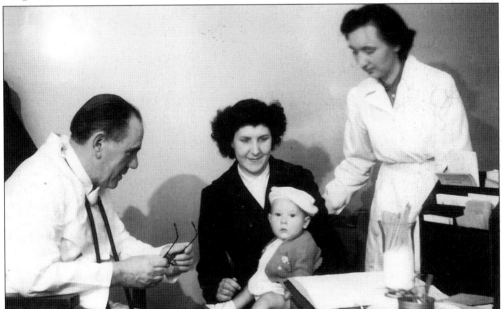

Dr R.S. Davidson and nurse at work in the clinic in 1957. Dr Davidson was appointed Medical Officer of Health in June 1943 succeeding Dr Glass who was in the post for twenty two years. The appointment also carried with it the duties of School Medical Officer for Farnworth. Dr Davidson also worked for twenty two years, retiring in November 1965. He and Dr Glass must have seen thousands of Farnworth children.

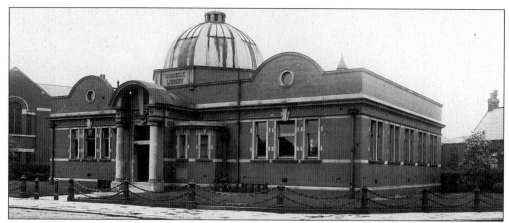

Farnworth Library 1939. The library was opened on 10 April 1911 by the donor of the site, Mr A. Topp, of Topp and Hindley. The Scottish philanthropist, Andrew Carnegie paid for the building, a cost of £5000 and there are likenesses in stone of these two benefactors above the entrance. Mr Topp said that it was 'a building designed to contain whatever was good, beautiful and true which would place before the people the best fruits of the best minds'.

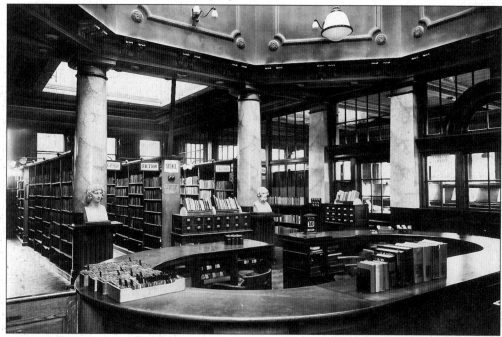

Inside the library 1930. The interior has undergone many changes and an extension was built in 1981. Mr Niemeyer was the first librarian, but many people will remember George Slinger, in charge from 1919-52, and Tom Boulter who came to Farnworth from Colchester in 1953 and was Borough Librarian until his tragically early death in 1969. Mr Boulter is remembered as a very popular figure who was actively involved in the work of many organisations in Farnworth including Rotary, fully living up to its object of Service Above Self. Pat Entwisle, 1969-74, was his successor and the last Borough Librarian before reorganisation in 1974 and one of only a few women Chief Librarians in the country at that time. Pat's father, grandfather, great grandfather and great uncle were all Farnworth Chief Fire Officers ( see page 22 ) and Pat served the Library Service with distinction for forty five years, and continues to work in local government.

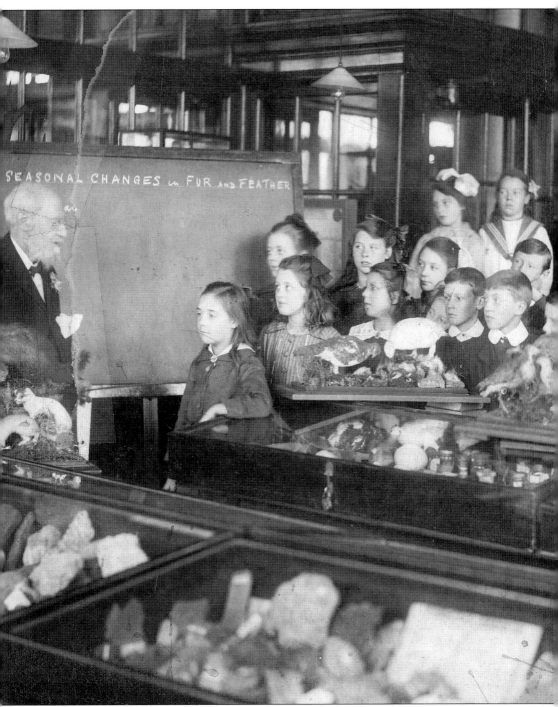

SEASONAL CHANGES in FUR and FEATHER

Mr Sessions at Farnworth library in October 1919. Mr Sessions presented the contents of the museum, formerly held in the library. He is over 80 in this photograph and gave lectures to school children in the library on three mornings each week. He visited many countries in his work calling on mission stations and picking up many curios and articles of interest on his travels, added to by friends and relatives. The museum was disbanded in the 1930s.

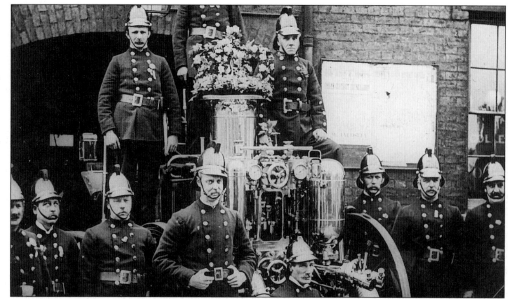

The new steam fire engine outside the fire station in Darley Street, 3 February 1899. The engine is decorated with flowers for its naming which was accompanied by the time honoured ceremony of the breaking of a bottle of wine. This engine was named Edith as a compliment to Miss Edith Sumner, daughter of Mr William Sumner JP, the then Chairman of the Council. (J. Pickford)

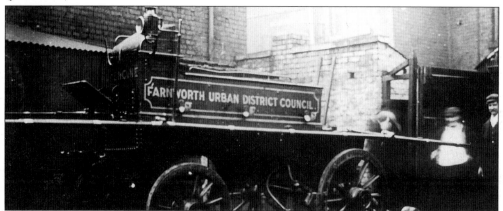

The manual engine used from 1868, photographed in 1899. The Fire Brigade was formed in 1864 following a fire at Barnes' Dixon Green Mill when a two storey building was destroyed and 90 people thrown out of work. Thomas Entwisle was the first Superintendent and the history of the brigade is the history of this family, whose members served the brigade and the town over many years. Thomas' son, James, succeeded him in 1886. James was injured on duty and died as a result. He was succeeded by his brother Alfred in 1906. Alfred's son Joseph was awarded the King's Police Medal for conspicuous bravery, along with Police Constable Richards of the Lancashire Constabulary, on the occasion of the Golden Lion Hotel fire on 9 May 1928 when three persons were burned to death. Joseph was Chief Officer from 1937 to 1939. When he left to be Chief Officer at Barnoldswick it was the first time there had been no Entwisle in the brigade. On the formation of the National Fire Brigade he was appointed Divisional Officer at Crewe but tragically was electrocuted while attending a house fire. His daughter Pat was the last Borough Librarian of Farnworth. ( J. Pickford)

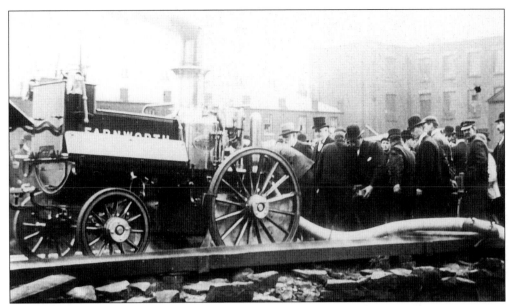

Nicholson and Sons yard, Albert Road in February 1899. After the inauguration ceremony several severe tests were made, witnessed by a large number of guests. Demonstrations showed the engine could throw steady jets at high pressure, a single jet being carried to a height of 170 feet. The engine was capable of filling a tank with 350 gallons of water in 80 seconds. In 1903 a further fire engine was purchased and named Anne after Miss Anne Nicholson, daughter of Mr N. Nicholson, a former Chairman of the Council. ( J. Pickford)

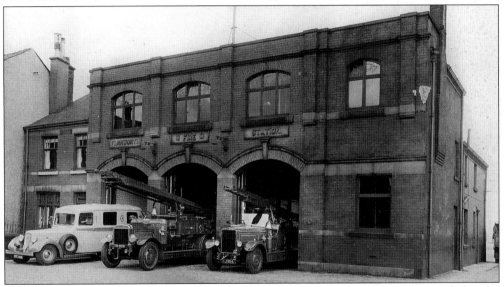

Fire Station, Albert Road 1939. New engines meant new accommodation was needed and a new fire station was opened in Albert Road 23 July 1914. Edith and Anne made the journey down from the old station in two and a half minutes. There was room for future machines, as well as existing horse-drawn engines. The naming of the engines continued, in 1925 Edith and Helen were christened and in 1935 an engine named Miss Olwen after the grand daughter of the Chairman, Mr J. Lord. The new fire station, further along the road, was opened in 1979 and the original Albert Road station was used as licensed premises for some time.

Crooks Mill No. 2, Denmark Mill, in Emlyn Street after being destroyed by fire on Sunday 6 February 1898. The aftermath was photographed by Mr Pickford. It had contained 16,000 spindles and employed 200 people. Mills were dangerous places as fires started easily in the presence of cotton, heat and oil. This fire was started by a spark from an oil lamp used by a worker in the engine house which ignited fluff or dust on the walls which were also saturated with oil. (J. Pickford)

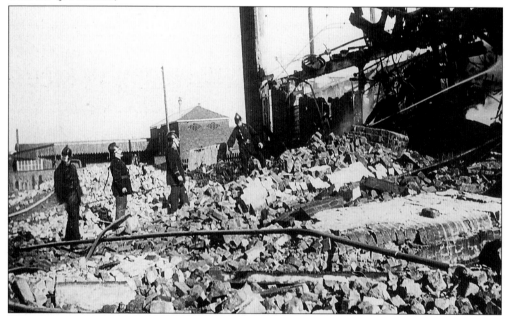

This photograph illustrates the difficulties and dangers of fire fighting at the time, as well as the bravery of the men. The Fire Brigade and Supt. Entwisle arrived at 6.50am with the hose car followed by the engine. Unfortunately, pressure from the mains was insufficient and spectators would not help work the hand pump to get water from Kershaw's mill lodge unless they were paid! Phetheans Mill Fire Brigade also helped, as well as Bolton but the building could not be saved. It was a dangerous operation with walls collapsing and roofs falling. Fireman Thomas Entwisle was knocked from a ladder when a wall collapsed and he fell 30 feet to the ground. (J. Pickford)

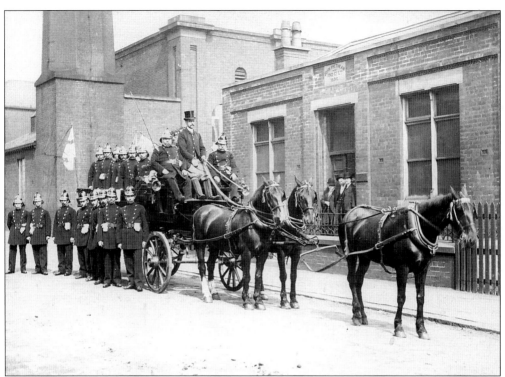

Phetheans Mill Fire Brigade, c. 1900. Before the fire brigade was established the town had to rely on the amateur brigades of Barnes's Mills and Crompton Paper Works. Later, mill brigades supplemented the work of the Fire Brigade, whose men worked during the day and lived in various parts of the town. Phetheans Mill Fire Brigade were close to hand when the fire at Crooks Mill nearby began. In the early days of the fire brigade, in case of fire the whistle at Prestwich's Mill was blown and the men in charge of the horses, no matter where they might be, would free them of their harness, jump on their backs and go galloping off to the station. Sometimes the horses would refuse to pass the trough at the junction of Gladstone Road and Bolton Road without a drink.

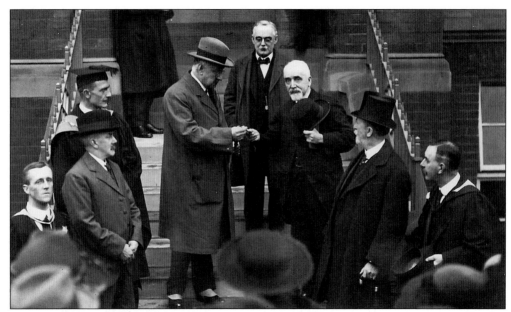

The opening of Farnworth Grammar School at 3pm on Wednesday 22 November 1922. The contractor, Mr J. Cocker, is seen presenting Mr J. Travis-Clegg, Chairman of the Lancashire Education Committee, with a gold key with which he unlocked the door and declared the building open. The Chairman of Governors, Councillor J. Kenyon is looking on and also in the picture is Councillor J. Stones, Chairman of Farnworth Education Committee and the Headmaster, James McCarter, on the extreme right. (*Farnworth Journal*)

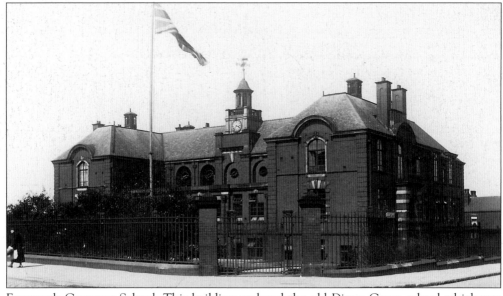

Farnworth Grammar School. This building replaced the old Dixon Green school which was situated in Albert Road, the location of the school since its founding in 1715, when education in Farnworth began (see page 62). On its opening, there were 156 boys and for the first time there were also girls on the school roll (37) but it was designed to accommodate 340 pupils. A new wing was added in 1939. Finally, 270 years of education came to an end in 1988 when the school was demolished.

# Two

# The Park:

## A Gift for the People

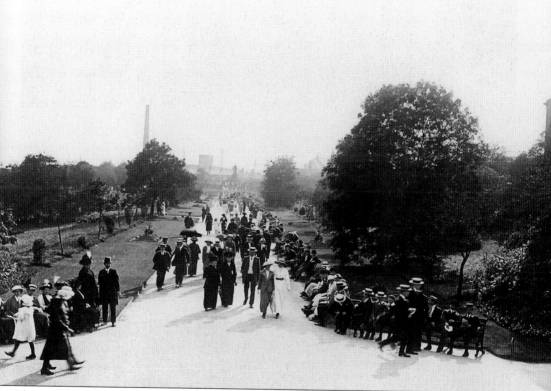

The Broadwalk, Farnworth Park, c. 1914. The park was the gift of Thomas Barnes, as part of the celebrations for his son's coming of age. Mr Barnes laid down certain conditions in connection with the use of the park: there should be no dancing; sale of intoxicating liquor was forbidden and there should be no lecturing, preaching or public meetings. The park was very popular and lived up to Mr Barnes wish that here 'the working men may have an opportunity of walking with their wives and families in the evenings of summer days, and perhaps also on Saturdays and on the Day of Rest, breathing as much fresh air as this smoky atmosphere can afford. It was opened on 12 October 1864 by the Rt. Hon. W.E. Gladstone, then Chancellor of the Exchequer, who was later to become Prime Minister. After the opening ceremony there was a banquet for 700 guests at which Mr Gladstone said that the park would never be perfectly enjoyed until something was done about the smoke nuisance in the towns, comments which would not have been popular with the mill and factory owners present, but ones which were prophetic and far sighted.

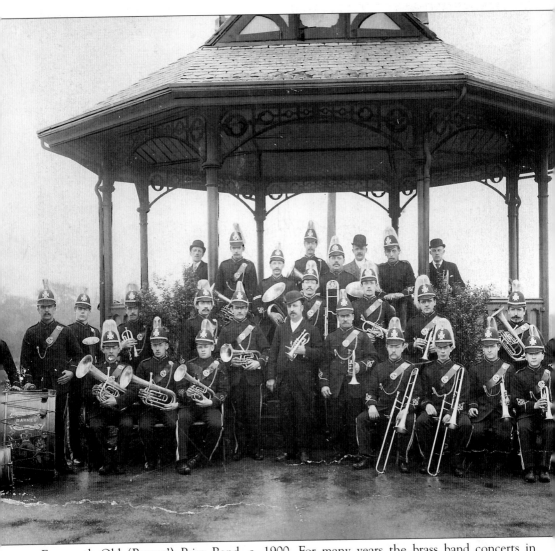

Farnworth Old (Barnes') Prize Band, c. 1900. For many years the brass band concerts in Farnworth Park and Ellesmere Recreation Ground were a regular feature of Farnworth life, taking place on Spring and Summer evenings and special occasions. Up to 4,000 people attended the concerts and a high standard of performance was expected. Bands received payment of £2 and 10 shillings per concert. The Band, resplendent in full uniform apart from four men, took part regularly along with Kearsley, Irwell Bank and Farnworth Reed Band. Barnes' band was the first band to be formed, in 1848, after male employees at Barnes' Mills expressed a wish to form a brass band representing the works. Thomas Barnes agreed to purchase the necessary instruments and uniforms and membership was restricted to employees of the firm.

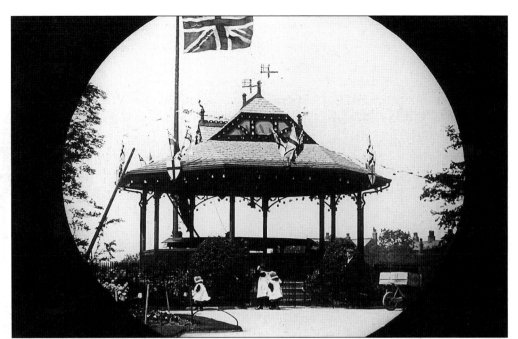

The bandstand, Farnworth Park, 1897. The new bandstand was formally opened on 11 July 1891 by the Irwell Bank Band. A suggestion that they join together with Farnworth Old (Barnes') Band to play the opening tune did not meet with the approval of the Old Band Committee and they declined to take part. Terms and conditions for putting on concerts were laid down by the Parks Committee and the wearing of uniforms, number in band and length of performance was checked at each event. At one concert in 1912 Barnes' Band only comprised of a few men and seven of these were without uniform. The concert was late starting and complaints were received. In mitigation the secretary explained that the seven were new men waiting for uniforms, two players had been injured in pit accidents that day, others were working on afternoon turn and two were firemen called away to a fire. The late start was due to waiting for three players working overtime, as well as waiting for the rain to stop. A new bandstand was erected in 1955. (J. Pickford)

## FARNWORTH PARK.

### Monday, May 9th, 1910,

# PROMENADE CONCERT

(WEATHER PERMITTING), BY THE

## IRWELL BANK PRIZE BAND

Conductor - Mr. Geo. Gittins.

### ℘ PROGRAMME. ℘

| | | |
|---|---|---|
| MARCH... ... ... "Zittella" ... ... ... | | Swift |
| OVERTURE ... ... "Spanish Carnival" ... ... | | Round |
| SELECTION ... ... "Il Trovatore" ... ... | | Verdi |
| VALSE ... ... ... "Smiling Beauties" ... ... | | Peccorini |
| FANTASIA ... "Memories of the Past" ... ... (National Airs) | | Rimmer |

"God Save the King."

### TO COMMENCE AT 7 O'CLOCK.

W. GLOVER, Central Printing Works, 7 Peel Street, Farnworth.

The boating lake, c. 1900. This was very popular with children. The lake was dredged in 1948 after falling into disrepair and was replaced by a paddling pool in 1949 which has also now gone. (J. Pickford)

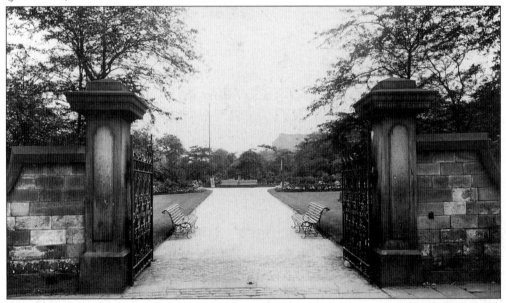

The Park Gates, Bolton Road, 1914. The Barnes family were closely associated with the growth of Farnworth and it is appropriate that they should be associated with the Park which is a permanent reminder of their influence. Thomas Barnes who gave the Park to the people of Farnworth was the son of James Rothwell Barnes, who along with Thomas Bonsor Crompton (see page 85), is known as the founder of Farnworth. He began manufacturing cotton goods in a fairly humble way, eventually becoming an employer of many people. He died in 1849 and the business was carried on by his son Thomas. In 1895 the Council erected a memorial to commemorate the gift of the Park.

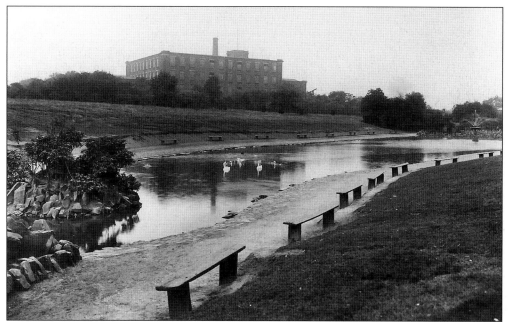

The lake in 1914 recorded on the occasion of the Park's Jubilee. On the day the Park was opened the streets were crowded with people, everywhere was decorated with flags and bunting and there was a procession which included the Lancashire Rifle Volunteers, as well as a group of workhouse children and a Mr William Chadwick, sitting in a milk float so that people could gaze on, and applaud, the first dairyman to deliver milk to householders.

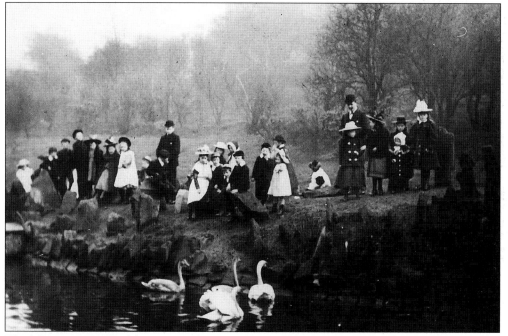

The lake, c. 1900. The lake measured 130 yards in length and was from 20 to 30 yards in width. On the lake and on the pond, situated a little to the east, there were swans and other aquatic fowl which children enjoyed feeding.

# DISTRICT OF FARNWORTH.

# PUBLIC PARK BOWLING GREEN.

## REGULATIONS.

1.---The Bowling Green will (weather permitting) be open every day, except Sunday, from One o'clock in the Afternoon up to the time when the Bell rings for Closing the Park.

2.---All Bowls must be given up to the Bowling Green Keeper within 15 minutes after the ringing of the Bell for Closing the Park.

3.---A charge of 1d. per hour will be made for each pair of Bowls; and the person to whom a Pair of Bowls shall have been lent will not be permitted to transfer them to any other person except through the Bowling Green Keeper, and on payment of a similar fee of 1d. by the person to whom the Bowls are transferred.

4.---Any person retaining the Bowls after the expiration of one hour will be charged for the same at the rate of 1d. per hour or any portion of an hour.

5.---Any person returning his bowls to the Bowling Green Keeper cannot again have a pair except on a further payment at the rate of 1d. per hour or any portion thereof.

6.---In cases where all the Bowls may be in use, and application is made for the accommodation of other persons desiring to bowl, the persons bowling shall be required, in the order in which they took out their bowls, and after the expiration of the time for which the bowls have been hired and the conclusion of the game they may then be playing, to give up their Bowls.

7.---All persons requiring the use of Bowls are particularly requested to ask for, and obtain from the Bowling Green Keeper, a Ticket, showing that they have paid for the hire of the Bowls, and to enter their names, residence, and time of hiring and returning the Bowls in the Bowls Book.

8.---Any person providing his own Bowls may, on payment of Two Shillings and Sixpence per annum, have the use of a private box, with a key, in which to keep his Bowls; but this payment will be in addition to the usual charge for bowling on the Green.

9.---Not more than 16 Players shall play on the Green at one time.

10.---No person will be allowed on the Green except he is Bowling.

11.---No person allowed on the Green with Clogs on.

12.---Any person swearing, using profane language, or gambling, will be expelled from the Green.

### BY ORDER.

## DAVID CROSSLEY,

Clerk.

Local Board Offices, Farnworth,
July 13th, 1885.

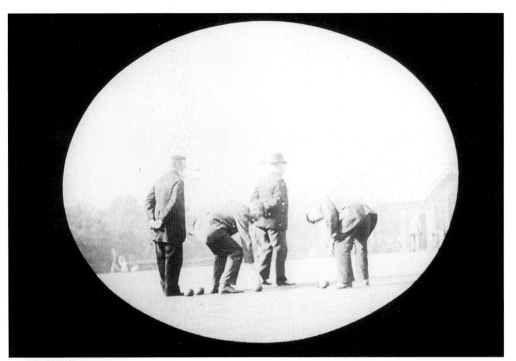

Bowlers, c. 1900. (J. Pickford)

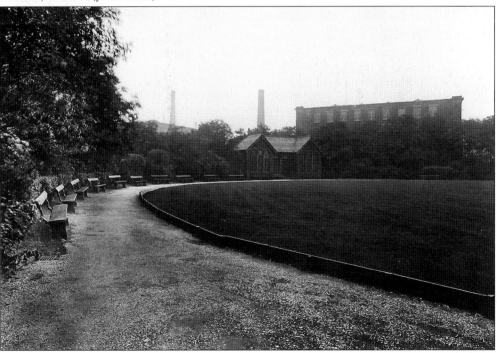

The bowling green, c. 1914. It is unusual in that it is circular. John Vose, in his book on crown greens (*Corner to Corner*, 1969), says, 'many a good bowler, having confidently accepted a bet that he can't reach in the corners has been shocked to discover that the Farnworth green is round'.

Robert Galloway, c. 1900. He was the first Park Superintendent, a job he kept for thirty two years. He lived in Almond Street, later moving to Gladstone Road. He was 80 when he died, following an illness contracted after he had tried to save a child from drowning in the Farnworth Park pool. He is interred in Farnworth cemetery. (J. Pickford)

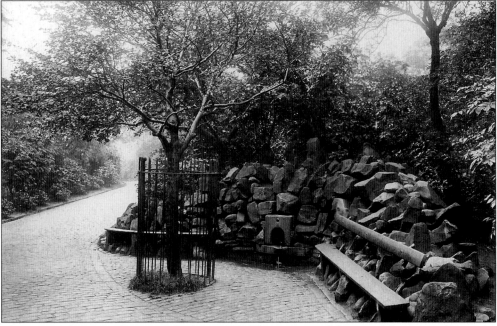

The spring of water in Farnworth Park, c. 1920. This was one of the original sources of water for the town. There were at one time only a few sources for domestic use, one of these being in the grounds of Darley Hall and known as Crowbank Well. Others were in the grounds of Leigh House, not far from King Street, Dial Post Brow and Clammerclough Well, between the Farnworth tunnel and the river.

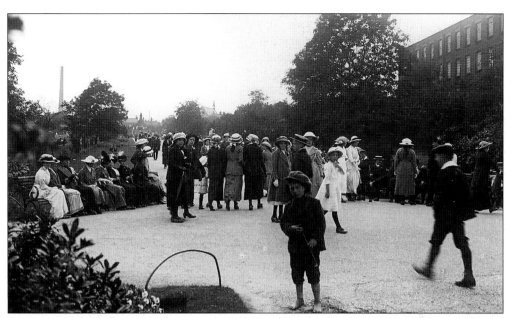

The Broadwalk, c. 1914. At one time, before this date, there were only half a dozen seats but gradually the whole walk was lined with them. It was Barnes' intention to provide a place for children to play in safety as he foresaw that Farnworth would soon have cottages and factories built on every square inch of land.

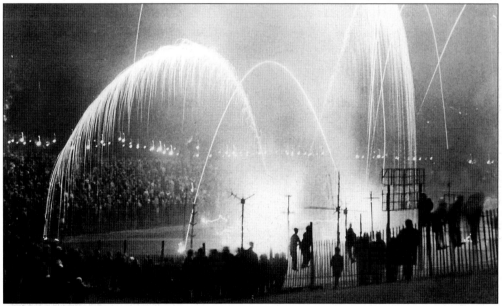

Whoosh, bang, the Park is 100 years old! A firework display in Farnworth Park on 12 October 1964, commemorating the opening of the park, to the day. The fireworks were lit in the hollow between the Broad Walk and Wellington Street and the event was attended by a crowd estimated to be between 5,000 and 7,000, a large proportion of which were children and teenagers. The display cost £200, or £5 a minute. For six weeks, leading up to the day, the park was illuminated with 1,000 coloured bulbs, illuminated animals and pictures, as well as floodlights. (*Bolton Evening News*)

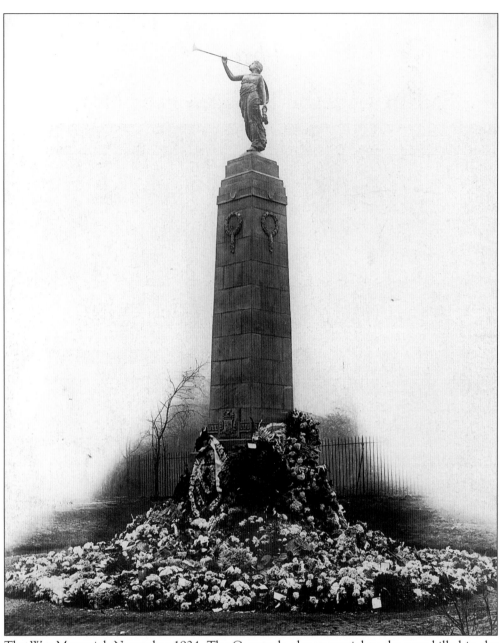

The War Memorial, November 1924. The Cenotaph, the memorial to the men killed in the First World War, was unveiled in November 1924. The figure in bronze on the top blows the trumpet of fame, holds in her hand a wreath and is crowned with laurel. There were 586 names on the original bronze plate, but others were added later, the last occasion being June 1993 when the name of John Darlington was added. Over 12,000 people attended the original ceremony with many hundreds carrying floral tributes. In September 1951 the Garden of Remembrance, the memorial to those who died in The Second World War, was dedicated by the Vicar of Farnworth, Revd Llew P. Burnett. The blood red cross was illuminated from 7.30 - 12.00 each night. At first the remembrance book was kept in a case in the garden but it was later transferred to the library where every Monday a new page is turned.

# Three

# People: Be Just and Fear Not

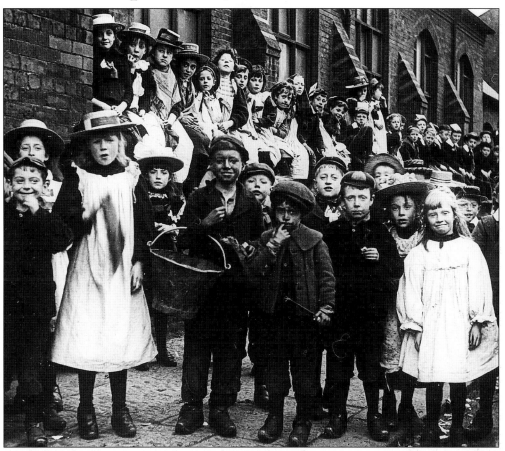

Election, 1900. Children outside a school in Farnworth with 'half-timers' in the front of the photograph in their working clothes. Half-time education, which meant children could work and attend school half-time was a major issue at the election, the minimum age for children working having been raised to 12 in 1899. The practise meant that more money came in to poor homes but children often fell asleep in lessons. It was 1918, though, before an Act abolished half-time labour but the terms were not fully operational until the early 1920s. (J. Pickford)

*That's not aw; when worn and bent wi' a mornin's work, to t'skoo we're sent,*
*To pick up theer in hauve a day a full day's larnin' as we may;*
*An' oft we feel so tired and fagged, so done an' drowsy, nipped and nagged*
*That o'er eaur lessons we crave for sleep, an' eaur een will shut, an slumber creep*
*Into eaur hearts , an then of course we'n to keep eaur dayleets oppen by force,*
*an sums and spellins an' scripture an' cane are aw mixed up in eaur bothered brain.*

From *The Voice Of The Half-timers* by Allen Clarke. (Teddy Ashton)

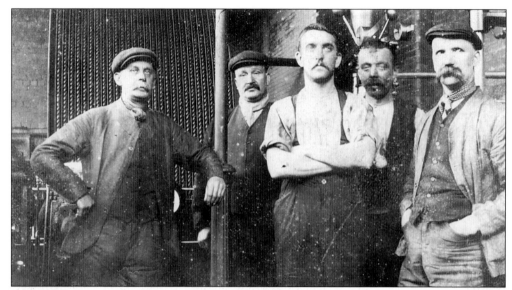

Mr Joseph Eli Markey, right, with staff of Messrs Barnes & Sons No. 2 Mill, where he completed thirty three years of service as an engineer. He lived at 17 Leinster Street and died in January 1942.

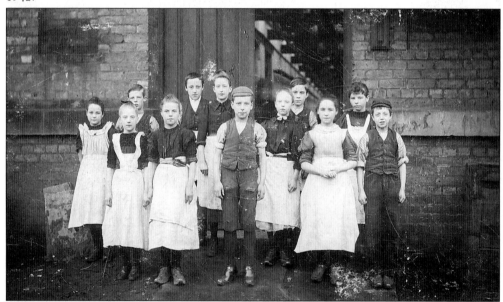

Half-timers (weavers) outside Horrockses, Crewdson and Co. Mill, Moses Gate. In 1900 the company was prosecuted for employing a boy, Joseph Jones, a half-timer who was only 11. The defence was that the Act of 1899 allowed children of 11 to be employed if the parents were poor. 'It was far more important to hundreds of thousands of children in Lancashire that they should be able to earn their 2s 6d or 2s 8d a week, than they should have a little extra education.' The boy's mother was a widow, her husband, a collier, having died eight years earlier leaving her with five young children, the oldest seven years and the youngest five weeks old. She had done washing and cleaning and in April consulted a specialist about her eyes and was advised to give up washing if she wished to retain her sight, her two sisters having gone quite blind.

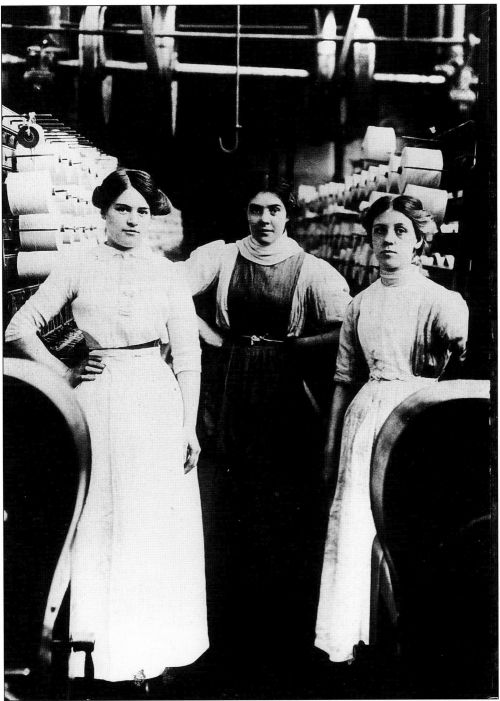

Barnes No. 3 Mill, c. 1920. These girls are, from left to right: Martha Dunn, Margaret Ann Riley and Edith Shaw and have their long hair worn up for safety. Golightly's in Market Street used to sell all the mill clothes, blouses, skirts, aprons, thick black woollen stockings, clogs and shawls. Just before the First World War there were forty six mills operating in Farnworth and something like 75% of the working population was employed in the textile industry.

W.A. (Pea) Morley, c. 1900. 'Pea' Morley was a well known local character who sold black peas. A saying grew up around him and mothers used to tell children who were reluctant to eat their food that they would end up like 'Pea' Morley's donkey. It was said that Morley had 'just managed to get his donkey living without food when it died'! An article in the *Farnworth Journal* of 9 May 1902 notes that W.A. Morley has claimed compensation for damages to his cart after a collision with a tram car. (J. Pickford)

The funeral of Robert Simpson 1907. Robert Simpson of Rawson Street was a bus conductor who drove a horse-drawn omnibus between Manchester and Bolton. Known as Bob's bus it was the only bus on this route. He died on 6 August 1907 and was interred in Farnworth cemetery.

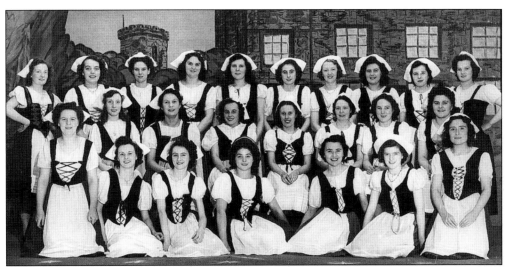

St Gregory's Amateur Operatic Society presented *The Yeoman of the Guard* in October 1948 at the Parochial Hall, Church Street. Among the citizens are: Marie Berry, Cecilia Berry, Mary Burke, Mabel Carney, Marie Cunningham, Molly Featherstone, Kathleen Finlay, Teresa Ford, Winefride Garrity, Kathleen Goodman, Winefride Haslam, Kathleen Johnson, Nellie Johnson, Kathleen Kirkman, Cecilia Liston, Imelda Mallon, Winefride McAllister, Joan McHugh, Julia McMullen, Cecilia Royle, Peggy Tonge, Winefride Towey, Joan Towey, Joan Wilson.

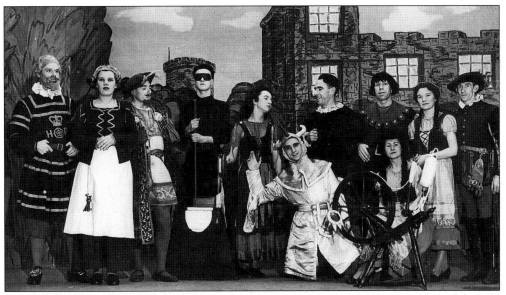

Frank Finlay CBE star of stage and screen, was born in Farnworth and first trod the boards in productions of local societies such as St Gregory's Amateur Operatic Society. He appeared in the *Yeoman of the Guard*, seen here third from left as Sir Richard Cholmondeley. John McNamara, later Father McNamara, was also in the production. Also in picture are John Kennedy, Margaret Axford, Mary Royle, Jim Callaghan, Leonard Hyland, J. Carney, Gerard Turner, Alan Burton, and Betty McFarlane.

Mr J.W. Pickford. Several of the photographs in this book were the work of Mr Pickford who was the manager of the *Farnworth Journal*, retiring in 1929 after fifty years service. He was a campaigning journalist with a love for Farnworth and a determination to improve it. He was ashamed of the town's high infant and maternal mortality rates. He also campaigned for the abolition of half-time education and for an improvement in the conditions in the mills. These concerns were reflected in the *Journal* and many of the social improvements in Farnworth owed their inspiration to him.

Three old men on the market. Owd Chum, Owd Honest John, Owd Bummy, Owd Peigh John and Owd Parson John were all Farnworth worthies of the past who were good for a story or anecdote, according to Ben Higginbotham's *Annals of Farnworth* (1911). (J. Pickford)

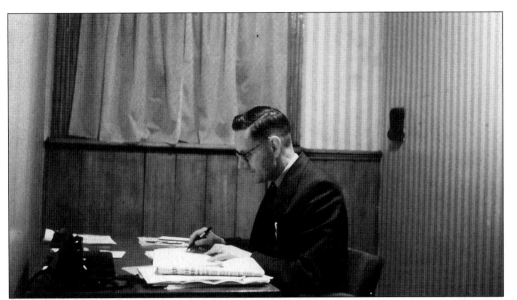

Mr Ralph Brownlow, manager of the *Farnworth Journal*, in 1957. He started work at Tillotson's Head Office in Bolton in 1912, came to Farnworth in 1921 and was appointed manager in January 1930. He lived in Rawson Street and retired in June 1962.

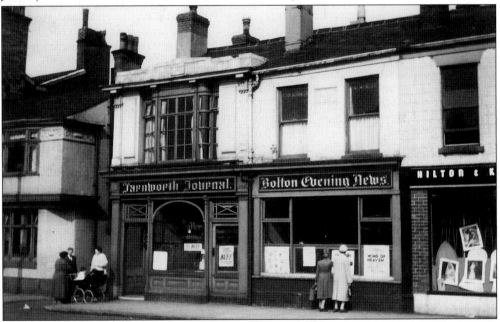

*Farnworth Journal* and *Bolton Evening News* offices, 89, Market Street, in 1957. The first weekly *Journal* was published at 73 and 113 Market Street 30 August 1873. A report in the first issue says, 'The Park Superintendent had been presented with a rare and beautiful specimen of a seagull he had received from Captain Clarke of Southport. The bird had begun to feel at home on the park lake and on Tuesday morning had taken flight', but, reported the *Journal*, 'We are disappointed to learn that it was shot by a gentleman in the neighbourhood of Fishpool'. Senior reporters with the *Journal* used to live on the premises. The paper ceased in 1975 and the offices closed in 1981. It is now Bees Cards.

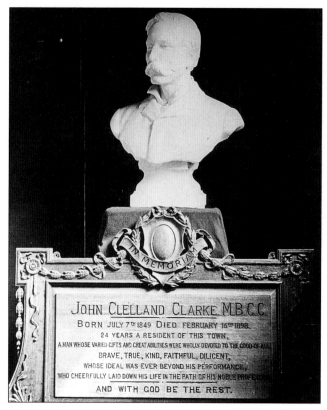

A memorial bust of Dr J.C. Clarke, St. Johns Church. Dr Clarke was a much loved and respected man, a native of Coleraine, Londonderry who came to Farnworth in 1873. He died in February 1898 following an attack of typhoid fever contracted at the Infectious Diseases Hospital, an institution which he helped to establish after a previous smallpox scare in 1888. He also campaigned in other ways. It was largely due to his efforts that a law was introduced to fight manufacturers who emitted black smoke from their factories. (J. Pickford)

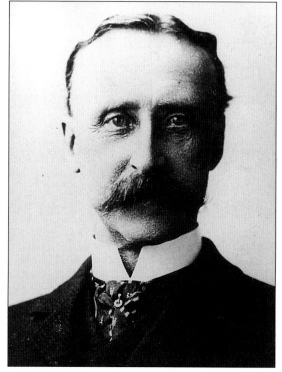

Mr J.E. Prestwich, c. 1900. His grandfather founded the Pandora mill in Longcauseway and the area grew rapidly with Topp and Hindley and Nuttalls Mills following. Mr Prestwich, with others, developed a technique for weatherproofing garments which were used by the first Arctic and Antarctic explorers. In 1920 the firm was amalgamated with Burberry's. The distinctive Burberry check coat lining is made in Farnworth by Woodrow Universal. He lived at Hope Villas next to the mill and died in 1932, aged 83, after retiring to Tunbridge Wells. (J. Pickford)

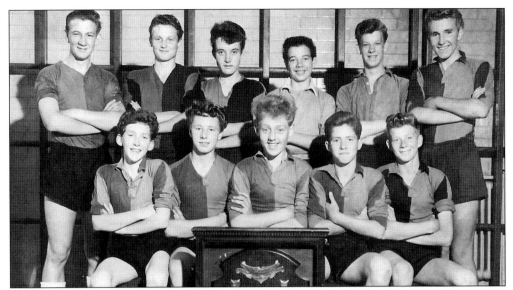

From Farnworth to Wembley. Alan Ball, one of the heroes of England's World Cup victory in 1966 was born in Farnworth on 12 May 1945, where he spent his early youth. He attended Farnworth Grammar School and the photograph shows him second from the right in the school team of 1958/9. He played for Farnworth Boys on many occasions but on leaving school suffered the severe disappointment of being rejected by Bolton Wanderers for whom he had already signed amateur forms. Wanderers missed out and he signed as a full time professional with Blackpool on his seventeenth birthday. Three months later he made his first team debut against Liverpool at Anfield. One of the sports halls at the Harper Green sports centre is named in his honour.

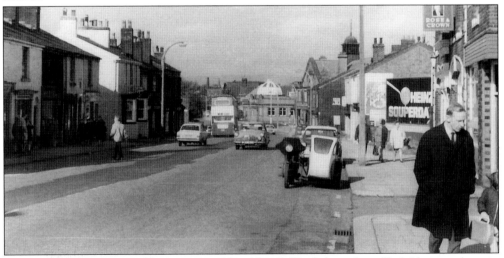

The Rose and Crown, Market Street, c. 1959. Alan Ball's father, also called Alan, was born in Farnworth in 1925 and was a joiner by trade but also a professional footballer, manager and coach. At one stage he also managed the Rose & Crown public house on Market Street, now called Scarlets. Alan Ball remembers that it had 'a massive back yard, ideal for practising his football skills. He had a distinguished sporting career at Farnworth Grammar School but homework consisted of kicking a ball against a wall'. (*It's All About A Ball* by Alan Ball, W. H. Allen, 1978)

George Tomlinson, seen here in the centre of this group, was Chairman of Farnworth Education Committee from 1928 to 1935 and the Farnworth MP from 1938 until his death in 1952. He served as Minister of Education from 1947 to 1951. He believed education to be 'the means that enables a person to live in the truest sense of the word and interpret life to the full'. In 1950 the *Farnworth Journal* said 'he represented all that is best in the North Country humour, humanity and honest to goodness hard work'. George Tomlinson was a half timer, a cotton weaver form the age of 12 to 25 and the last half timer to become a Minister of State. He served Farnworth well, understanding the nature of its people and how most earned their living. He was a man of the people as well as a good friend of the King and Queen. George Tomlinson School was opened by his widow on 31 October 1953. (*Farnworth Journal*)

Peter Greenhalgh, a photographer with a shop in Market Street, in 1900. He was one of the first people in the area to give lectures with lantern slides. In 1894 he offered lantern slide lectures on the following subjects; Round Britain in a Yacht, Fifty wonders in Nature and Art, The Child - What Will He Become?, A Tour Through the Lake District and The Life and Labours of James Calvert, missionary to Fiji. On 22 March 1884 there was a commotion when his apparatus exploded during a magic lantern show at Holland's School .
(J. Pickford)

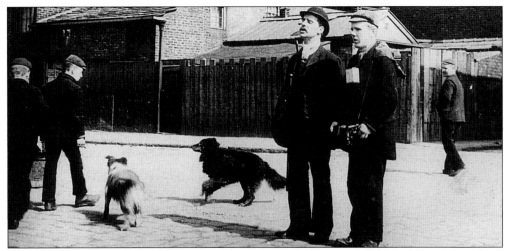

Blind Singers, c. 1900, at the side of the Co-operative Stores. Allen Clarke in his book *Moorlands and Memories* (1924) remembers the blind musician who played an old harmonium in the street and sang *The Blind Boy's Been at Play*, *Pull for the Shore*, and other plaintive songs and hymns. With no other means of income it was necessary to obtain money in this way. One blind Farnworth musician was John Carpenter Heal of Darley Grove, blinded whilst helping to build the Rawsons Arms Hotel. In order to support his family he bought a Victorian organ and accompanied by a monkey went round the streets of Farnworth collecting money. (J Pickford)

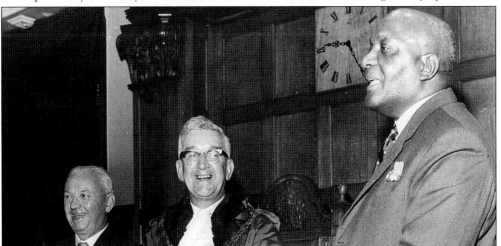

The Freedom of the Borough, 21 September 1916. The highest honour that any town can bestow, was conferred upon Dr Victor St Clair Lucas (right) and Alderman James Stevenson (centre) at a ceremony in the Town Hall. The Mayor, Councillor H. Brindle is seen presenting scrolls to these men who devoted their lives to serving the town and its people. Alderman Stevenson was born in Farnworth and served on the Council for over forty years and had been part and parcel of its progress. Dr Lucas was born in Trinidad and came to Farnworth in 1919 as a family doctor, with his home and surgery at The Croft, Buckley Lane. He worked for forty one years and made a tremendous impact as a doctor, going out of his way to help people, showing great understanding and sympathy, especially during the hard days of the depression. On his death, in 1963, there were many tributes to his wonderful spirit and over the years the testaments to his importance and worth to the community have continued. A window in All Saints Church was dedicated to his memory in October 1970.

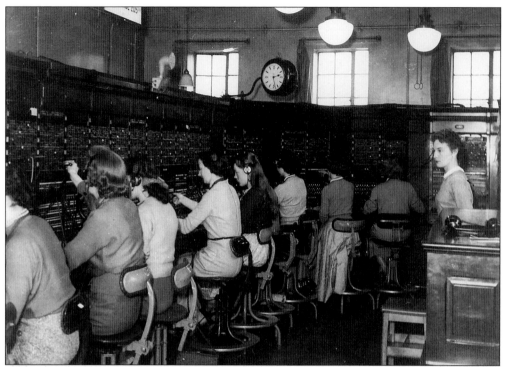

Telephone exchange, 1957.

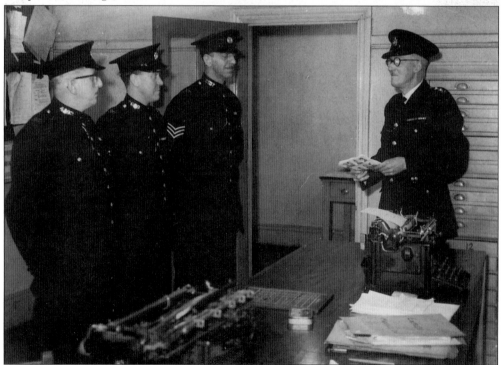

Special Constables in Farnworth Police Station, 1957. Joe Wadsworth is on the right, on the left is Frank Cheadle, a butcher by trade.

# Four

# Streets

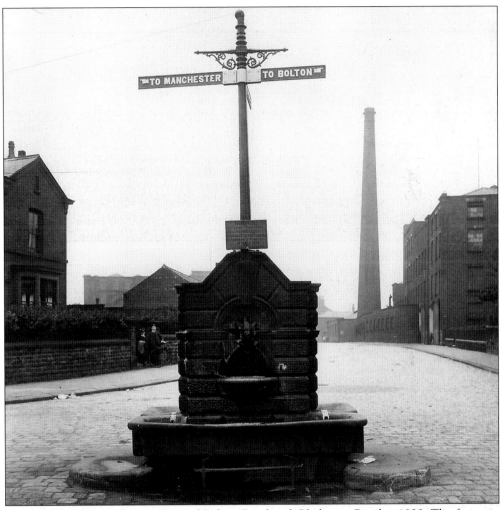

Drinking fountain at the junction of Bolton Road and Gladstone Road, c.1920. The fountain was erected in 1865 on the site of an old finger post on Dial Post Brow. It was made of Yorkshire stone with a basin of Aberdeen granite over which was a circular niche. Water was fed from the figure of a dolphin, the overflow ran into a cattle trough eight feet long and the overflow again from this to two dog troughs. There were two galvanised iron cups for drinking purposes. The fountain had an inscription on it which said, 'Presented by Mrs T.B. Crompton, of Farnworth, 1864'. Later it also had a notice which said, 'Any person or persons standing at this trough wasting water on the highway, interfering with or damaging the fountain will be prosecuted'. It was removed in March 1929 although it had been without water for some years. Barnes' No 1 Mill is on the right.

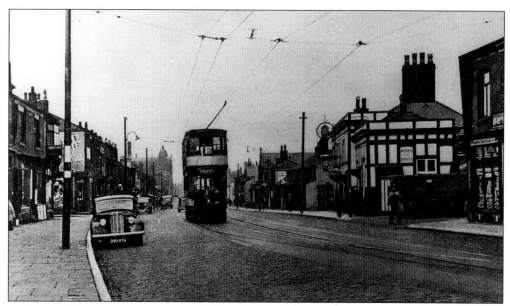

Higher Market Street in 1936, near The Black Horse pub. The tram is one of the former UDC trams which were sold to South Lancashire Tramways. They were used on the 'F' route, Bolton to Farnworth, until replaced by buses in 1944.

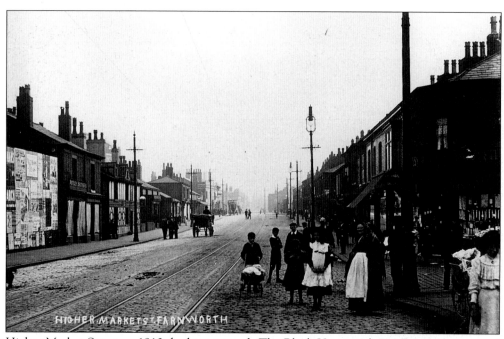

Higher Market Street, c. 1910, looking towards The Black Horse with Joe Berry's drapers and outfitters on the right hand side, on the corner of Frederick Street.

# The Leading Draper & Outfitter.

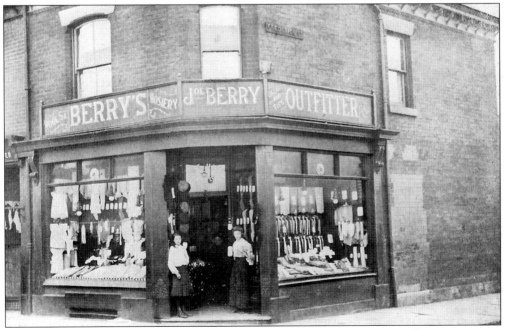

Advertisement for Joe Berry's Drapers from Alldred's *Picture Views of Farnworth*, 1914.

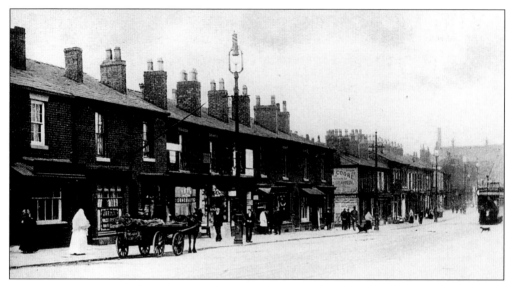

A postcard view of Market Street, dated 1907, looking towards the Co-op. James Billington had a hairdresser's shop at 51, Higher Market Street and was appointed as a hangman in 1884. From then until his death in December 1901 he carried out many executions. In the shop he had a sign which read, 'Friends don't swear. It is a sinful and vile habit. You may swear yourselves in hell but you cannot swear yourselves out of it'. He never talked to the press and did very well out of the many journalists who came for a haircut or shave and tried to engage him in conversation. He was later the licensee of the Derby Hotel, Churchgate and was succeeded as a hangman by his sons William and Thomas.

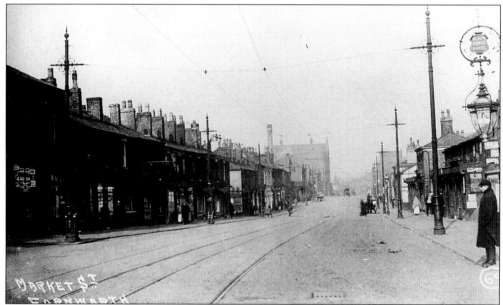

A scene in 1920 with The Black Horse on the right. This was then, and still is today, one of the best known landmarks, not least because then it was also a busy tram stop. According to deeds held by the then owners Magee Marshall it was probably the oldest hostelry in Farnworth and Kearsley, dating from 1789. It was possibly a public house even before that when it was owned by the Hulton family.

# BLACK HORSE HOTEL,
## HIGHER MARKET STREET,
### FARNWORTH.

## MRS. E. ROSTRON, Proprietress.

# BREWER,
## WINE & SPIRIT MERCHANT,

**AND PURVEYOR TO THEIR ROYAL HIGHNESSES THE
PRINCE AND PRINCESS OF WALES.**

Refreshment Contractor for Banquets, Balls, Wedding
Breakfasts, and Coming of Age Celebrations,
Agricultural Shows, &c., &c.

Marquees, with all Appurtenances, for Outside Festivals, Volunteer
Encampments, &c.

This Hotel is conveniently situated, being the
starting-place of all trams to Bolton, which run every
fifteen minutes.

BRANCH ESTABLISHMENTS:

**MRS. E. ROSTRON,
Proprietress.**

BRIDGE INN, BRIDGE STREET, BOLTON.

FOUNDERS' ARMS, St. GEORGE'S ST., BOLTON.

GIBRALTAR ROCK, PIKES LANE, BOLTON.

KING'S HEAD HOTEL, DEANE.

BOAT HOUSE HOTEL, Magazines, New Brighton.

This Hotel is pleasantly situated, having an excellent sea view.     Every accommodation for visitors.

There are Private and Public Bowling Greens in connection with the
above Hotel.     Rural Scenery and Country Air.

An advertisement for The Black Horse from Axon's 1881 Directory of Bolton and District.

# HIBBERT'S

*Tel. 9x3.*

## Dining & Refreshment Rooms.

The Best and Oldest in Farnworth.

### Private Parties Catered for on the Premises.

## 4a, Market Street, Farnworth.

(OPPOSITE HOLLAND'S SCHOOL).

**Commercial Room.**                    **Billiards.**

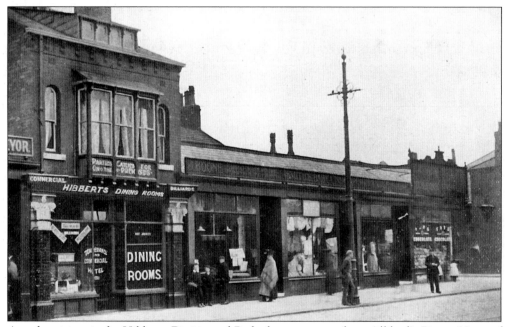

An advertisement for Hibberts Dining and Refreshment rooms from Alldred's *Picture Views of Farnworth*, 1914.

54

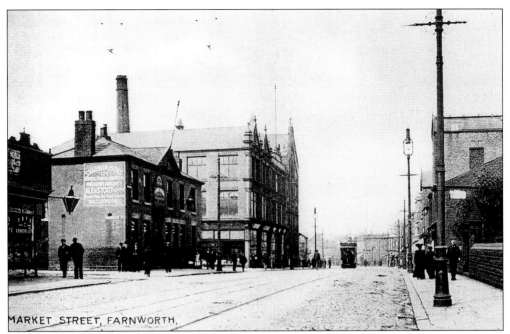

Market Street. Next to the Co-op is The Queens Hotel, to the left was Hibbert's Dining Rooms and a little further along the sports shop owned by Tom Buchan. Buchan played for Bolton Wanderers from 1914 to 1924, playing in every position except full back. The shop is now the long established Salters sports shop.

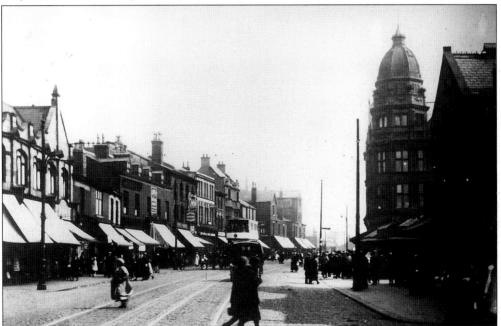

Market Street in its heyday, c. 1930, looking towards Kearsley with the Co-op dominating the skyline. On the right is the shop of Jack Morris, prize winning black pudding maker and organiser of Britain's first Black Pudding competition, held at Farnworth Cricket Club in 1970. Read all about it in *The Other Black Beauty* by Jack Morris.

## Rushtons' Surgical Department.

We keep almost every article of this character that you could possibly require. Bandages, Lint, Cotton Wadding Elastic Bandages and Stockings, Enema and other Syringes, Belts, Trusses, Douches, &c.

## Baby's Needs.

We have everything that Baby needs, including Feeding Bottles, Tubing, Teats, Puff Boxes, Sponges, &c.

## Toilet Requirements.

Everything for the Toilet. Soaps, Sponges, Bath Brushes, Tooth Brushes, Powders and Pastes, Toilet Creams, Powders, &c.

## Dispensing of Prescriptions.

London Qualifications. We pride ourselves upon the unique accuracy and purity of our medicines.

## Optical and Photographic.

These Departments are conducted in the best possible manner, while prices are uniformly moderate.

## The Largest Cash Chemists

in the District. Our stock is always fresh and up-to-date because it is constantly being turned over. Our low prices are the result of our buying policy.

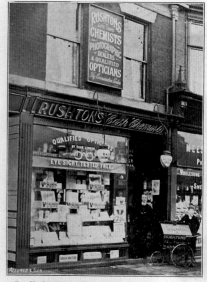

Our Market Street Shop, established by Thos. Morris 50 years ago (Eyesight Tested free of charge).

**Rushtons,** Cash Chemists, 77 Albert Road & Market St., FARNWORTH.

---

We make a speciality of

# COD LIVER OIL

It is the purest and sweetest obtainable, and quite fresh each season. No old oil mixed with ours. For those who cannot take the oil, we make

## Cod Liver Oil Emulsion

which is quite palatable and nice taking. In fact children like it.

1s. size for 7d.
2/6 size for 1s.
4/6 size for 1/9.

## Extract of Malt & Cod Liver Oil

VERY STRENGTHENING,
1s. & 1/9 per bottle.

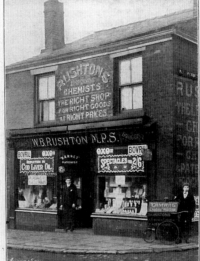

ALBERT ROAD SHOP.

# CHEMICAL FOOD
### (DR. PARRISH)

For delicate & weak children
It forms New, Rich,
Red Blood. . . .

**Price 5d., 9d., & 1/3 (1lb size)**

**GREY HAIR is a sign of age.**

# RUSHTONS'
# HAIR RESTORER

Is an easy remedy. It is not a dye. It restores grey or faded hair to its natural colour. . . . .

**PRICE 1/- PER BOTTLE.**

# Rushtons, Cash Chemists and Opticians, 77 Albert Road, and 118 Market Street, Farnworth.

An advertisement for Rushton's Chemists from Alldred's *Picture Views of Farnworth*, 1914.

56

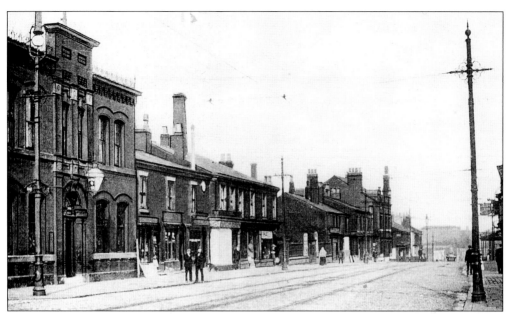

Postcard of Market Street looking towards Bolton, dated 14 August 1907 . The pub on the far left was The Horse Shoe Hotel and further down are the gates of the Sunday school, used by Mellings Bakery as a staff canteen. It was later demolished to make way for a DIY store.

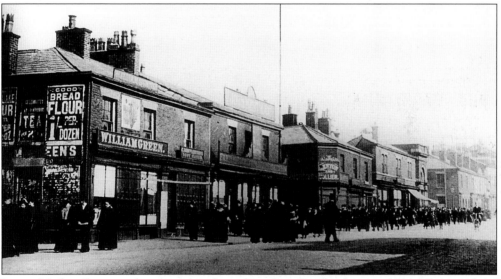

Lower Market Street and everyone is dressed in their Sunday best, c. 1914. The parade of younger people up and down the pavements of Market Street was known as 'the monkey run' and was the recognised place for girls and youths to get to know each other. There was a quality and a quantity side, posh and cheap,also known as a 'bob' and a 'tanner' side. The left hand side, towards Bolton, was the common side, the opposite side shown in the photograph offered more class. Social demarcation was strict and no one who belonged to the cheap side would walk on the posh side. The greetings on the cheap side were of the following kind, 'How's your mother for soap?' to which the girl would reply (if at all), 'Up t'neck in lather', how it was said being all important! Young men on the posh side wore pots or trilby hats which they would politely raise and then engage in conversation.

# STUDY YOUR APPEARANCE.

**EVERY MAN**—if he has any pride or ambition at all—desires to be well dressed and to look smart, yet good dressing need not be expensive, providing he shops at **Tom Horsfield's.**

**NOTED** for up-to-date goods of the best quality at prices that cannot be beaten. You cannot afford to be without our Famous Hats and Caps.

**GENTS' TIES** in every shape and pattern—including Crepe de Chene and Irish Poplin.

**NOTED** far and wide for Union and Wool Shirts. These particular shirts only obtainable at **Horsfield's**—ask to see one anytime. Regular knockouts!

My only address:

**94 MARKET STREET,
FARNWORTH. : : :**

My only address:

**94 MARKET STREET,
: : : FARNWORTH.**

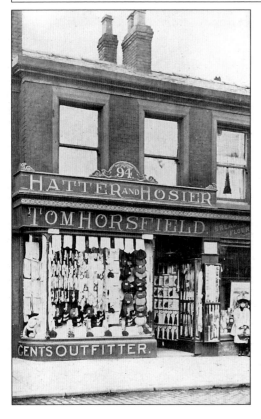

An advertisement for Horsfield's from Alldred's *Picture Views of Farnworth*, 1914.

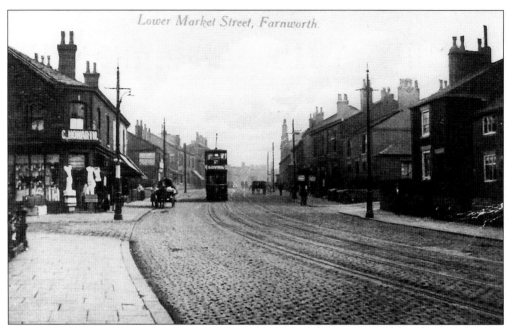

Howarth's shop on the corner of Rawson Street and Market Street, c. 1910.

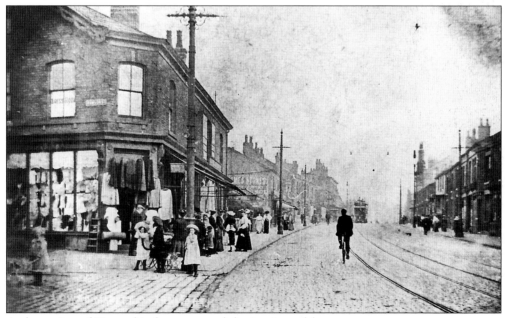

A closer view of Howarth's shop at a much busier time of day.

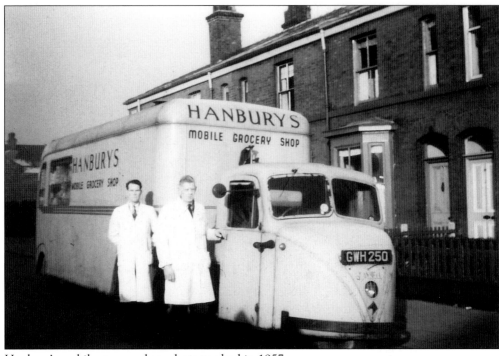

Hanbury's mobile grocery shop photographed in 1957.

An advertisement for Hanbury's from Alldred's *Picture Views of Farnworth*, 1914.

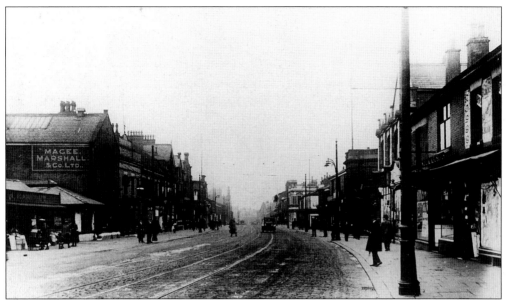

Hanbury's shop is just visible on the left hand corner in this view of the edge of the market between King Street and Brackley Street, c. 1930. The ubiquitous Magee Marshall ales could be drunk here and the pub next to Hanbury's was the Old Bowling Green Hotel (see p.82).

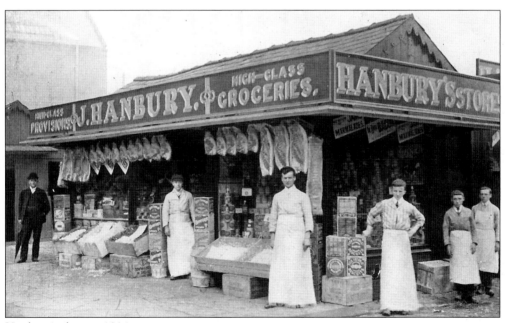

Hanbury's shop in 1914.

Albert Road. This postcard is dated 31 December 1907 and the writer mentions 'seeing a huge blaze of a cotton mill the other night'. Two important buildings are shown: on the right is the schoolmaster's house which adjoined Dixon Green Grammar School, the forerunner of Farnworth Grammar School. Built in 1860 it replaced, and was built on the site of the original school. The house is now privately owned and has been extended. Bartonville, a former doctor's house, which was demolished in 1973, is on the left.

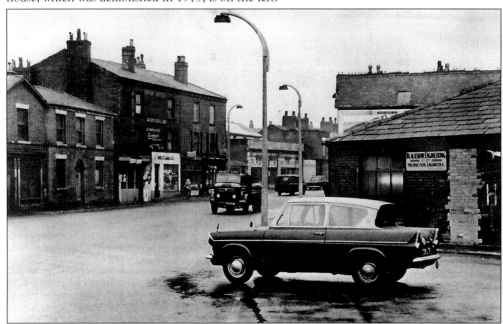

Albert Road, 1963. This road was formerly known as Nan Lane and was renamed in 1863 after Prince Albert drove along there on his way from Worsley to Barrow Bridge. It was fifty years before Farnworth was again honoured with the presence of Royalty, the first official visit being that of George IV and Queen Mary in July 1913.

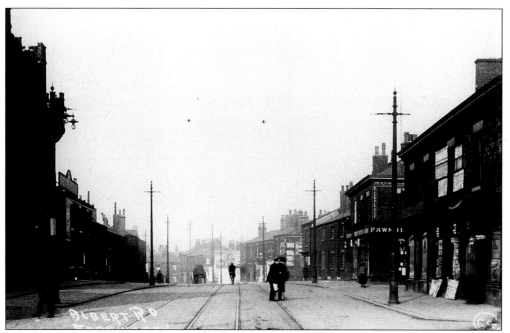

Albert Road, 1907. On the right hand side was the pawnbrokers shop belonging to Mrs Alice Derbyshire, at number 131. She also had a shop at 184, Bridgewater Street.

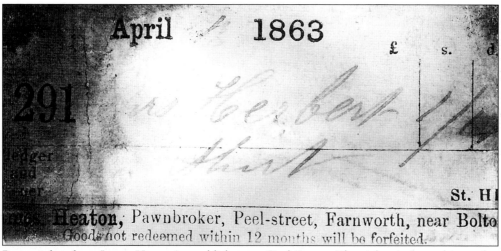

Pawn ticket from James Heaton's establishment, Peel Street. The ticket is for a shirt, value 1/4d, pledged by Mrs Herbert. The pawnbroker's shop was always referred to as Uncle's and Monday mornings was the popular time for pawning items especially clothing for best. In the 1881 Directory there are five brokers listed; Derbyshire Bannister, Ellesmere Street; George Makin, 157 Market Street; Emma Ramsbottom, 19 and 21 Cross Street, Francis Shipperbottom, Blackhorse Street; and John Yates, 70 Gladstone Road.

Plodder Lane in 1939 showing the Junior Council School on the right. Farnworth's famous comedienne, Hylda Baker, went to the school. Born at 23 Ashworth Street, her grandmother's house, in 1905, she went on the stage at an early age, spending many years touring the country in Variety before giving it up and buying a fish and chip shop in Plodder Lane. The shop is still there but with a more extensive and oriental menu. In 1955 she returned to show business and was said to be earning £1,000 a week in 1956 with many more successful years before her death in May 1986. Hylda was the eldest of the seven children of Harold 'Chucky' Baker. Her mother was a tailoress and her sister was Lady Captain of Farnworth and Great Lever Golf Club in 1975. (*Bolton Evening News*)

Plodder Lane, c. 1900, when it was really in the country. Flanked by high hedges and banks of Farnworth ferns there were thatched cottages here and there and the lonely old lane was popular for courting. Plodder Lane railway station, built in 1872 was very much a country station but the trains were not very frequent. It became a residential area for colliers and factory workers and later new housing changed its character completely. (J. Pickford)

Plodder Lane, 1939. The origin of the name is shrouded in mystery though one suggestion is that it originates from the days when the people of Farnworth carried coffins along this route to Deane Church, before St John's Church was consecrated in 1826. The procession always stopped to rest the coffins on a stone which, by long usage, became known as the ' burying stone', located near Exeter Avenue. Dixon Green was the industrial area and workers were employed at two collieries in Mossfield Road and at Barnes' Mills in Gladstone Road and Glynne Street. The Glynne Street Mill was taken over by Norris' Timber Merchants and has just been demolished to make way for housing.

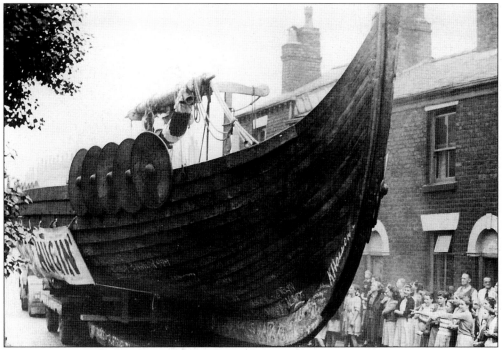

Plodder Lane, September 1949. The Viking ship, *Hugin*, which had sailed from Denmark to Britain, being transported along Plodder Lane on its way to Blackpool for an exhibition. (*Bolton Evening News*)

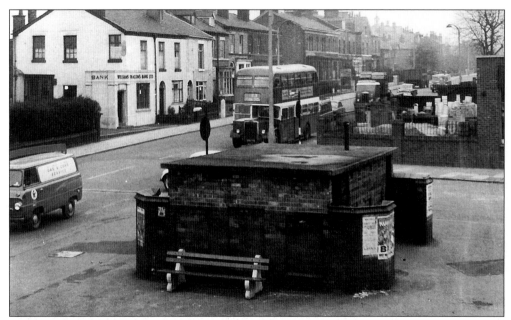

Moses Gate November 1963. The toilets were opened in 1936 and were on a small island described, in 1963, as a miserable square and the scene of many traffic problems. The traffic lights were installed in 1943 but twenty years later 2,500 vehicles an hour were having to negotiate the island. The toilets, which often proved to be a painful obstacle when alighting from a bus in a hurry, were demolished. The island was replaced by a small garden and the traffic re-routed. (*Bolton Evening News*)

Moses Gate, c. 1910. The origin of the name has led to much discussion. The most popular suggestion is that it gets its name from one of the best-known keepers of the tollgate which was situated there, a man called Moses. The other explanation is that it simply means the way to the mosses. Not everyone would agree that this is a gateway to 'a promised land ', as the name might imply! The gate was removed at midnight on 1 November 1876 and Farnworth Brass Band passed through playing *Home Again*.

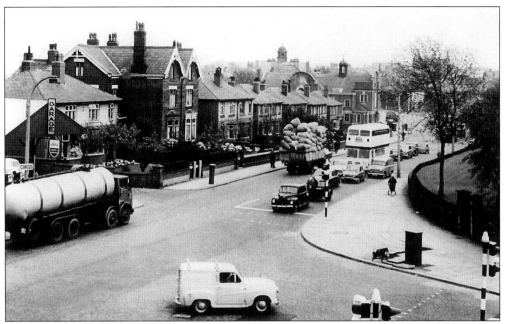

The corner of Gladstone Road and Bolton Road just after new traffic lights were installed on 28 May 1963. Marlands Garage was there for many years on part of the site of Birch House (see page 77). (*Bolton Evening News*)

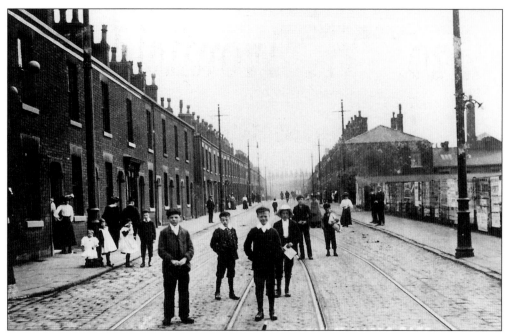

Egerton Street. This postcard is dated 4 September 1909 and was sent by Mr Hulme of 17, Harrowby Street. In March 1875 Robert West, Robert Martin and Joseph Monks were fined one shilling each and costs for obstructing the highway by playing piggy.

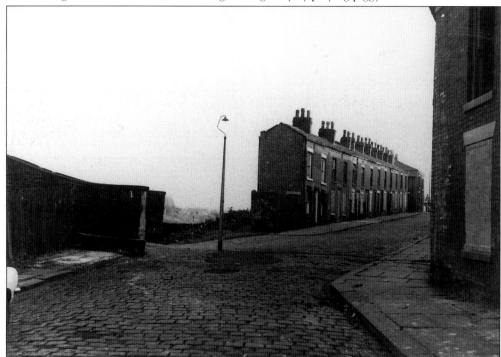

Ash Street in 1972 shortly before demolition. Ash Street, Oak Street and Spring Street were at the rear of Farnworth Grammar School. New housing replaced these dwellings as Farnworth continued its housing improvement programme.

# Geo. W. Ironfield,

## Practical Tailor & Ladies' Costumier.

Funeral Orders in 12 Hours.       Own Cloth made up. . . . .
Repairs. . . . .                   Hats and Caps. . . . . .
Pressing and Cleaning. .           Orders by post promptly attended to.

## Gents' Suits from 30/-.    Ladies' Costumes from 35/-

MADE TO ORDER ON THE PREMISES.

*GOOD FIT AND WORKMANSHIP GUARANTEED.*

## 49 Egerton Street, Moses Gate, Farnworth.

Bolton Representative: Mr. H. ARMITT,

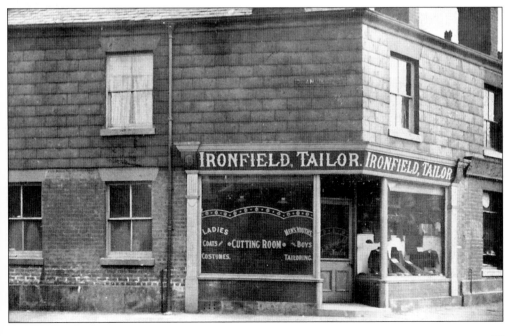

Longcauseway, c. 1900. In the early nineteenth century Longcauseway was often covered with water. At night, escaping gases from the coal pits beneath the road and the water on the surface together produced a strange effect of shimmering light called Will o'th'Wisp. This caused terror in many persons walking along Longcauseway and gave rise to the idea that the road was haunted. Will-o'th'Wisp sometimes appeared in the shape of a bright white light and a tradition arose that in Longcauseway at night a white rabbit could be seen running about. It is also recorded that in the early nineteenth century skylarks were so numerous in the district that one locality was named 'Lark Hill', a name retained to the present day. (J. Pickford)

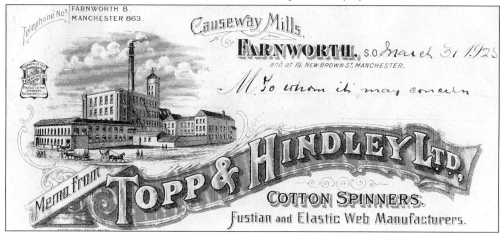

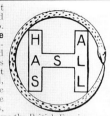

EVERYONE knows by this time that C. H. Hassall has removed to new and more imposing premises. The photo. depicts **Dr. Hassall's Herbal Medicine Stores** at the Market Street end of Longcauseway, Farnworth, where you can be supplied with the best medicines, pills and ointments obtainable, many of which have stood the test of over forty years. The prices are low, and, considering the value of the goods, they are only nominal. If you want toilet requisites, we can supply our best Hair and Toilet requisites, which are widely known and are sent all all over the British Empire.

**Dr. Hassall** may justly be called the Hair King, having succeeded where others have failed. His treatment has stood the test for over forty years and has never been known to fail. Dr. Hassall gives free advice to all, and his charge is moderate for treatment, both internal and external Dr. Hassall uses no dummy blocks, his own photograph and portraits of those to whom he has restored luxuriant hair is the best testimony.

**Dr. Hassail** is the sole inventor and maker of the best Herb Packets for making the best Herbal Medicines in the world. They comprise some 60 varieties, which are justly famed for their curative action, and are being sent to all parts of the world where the English language is spoken. Dr. Hassall offer free personal advice to all, but will not advise free by letter.

List on application from . . .

# Dr. HASSALL, 11-13 Longcausway, Farnworth, R.S.O.

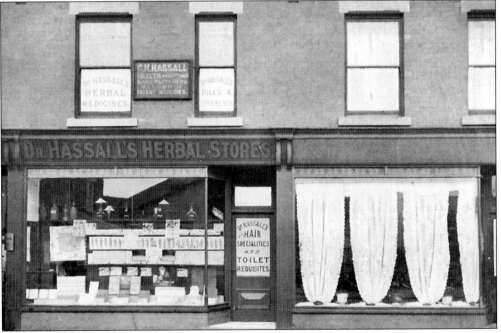

Dr Hassall's shop on the corner of Longcauseway and Market Street in 1914. There was no National Health Service and people often turned to home doctoring and the herbalist's shop. There was a scheme for those at work to pay weekly to be on a doctor's private list of patients called the Panel and until recently a sign between the windows reading ,'Drink more herbs and laugh at the Panel', was still visible. If there's owt at aw to do wi' yo' just yo' try A GRADELY DOCTOR. An' yo'll do th' best day's wark yo ever did in yo'r life, for he'll cure yo and mek yo' GRADELY WEEL!, read an advertisement for Dr Hassall. Dr Hassall's hair restorer and hair tonic were both 1 shilling a bottle.

71

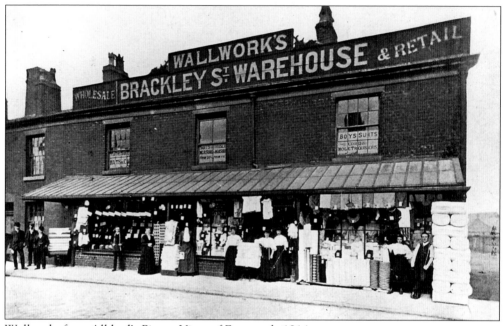

Wallworks from Alldred's *Picture Views of Farnworth*, 1914.

# WALLWORKS,

Tailors, Drapers, Outfitters,
and General Warehousemen.

## Brackley Street Warehouse,
## Farnworth.

If you require any article in : : Drapery, Underclothing, Boys' : Youths' or Men's Suits, visit us at Brackley Street Warehouse : and you will save money. We have **over £2,000 worth** of : Clothing & Drapery to choose from

It is an utter impossibility to shew all our goods in the windows, so if you do not see what you require just step inside and look.

**WE GIVE BEST POSSIBLE VALUE FOR CASH.**

We give 2ozs. of Tea with every 2/6 spent at once.

Brackley Street, north side, c. 1960. Tildesley's, established 1874, had a shoe shop in Brackley Street and clogs were the mainstay of the business. It closed in 1974 due to redevelopment. The Brackley Arms was nicknamed 'The Mop'.

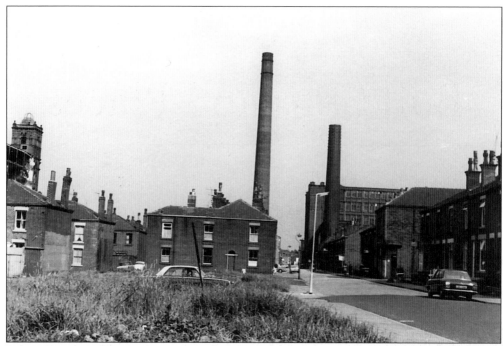

Bolton Textile Mills, Cawdor Street, Edward Street and Victoria Street, c. 1972.

Central Avenue 1962. Farnworth's new housing was modelled on 'garden city' lines with the roads tree lined and spaciously set out.

# *Five*
# Buildings and Places

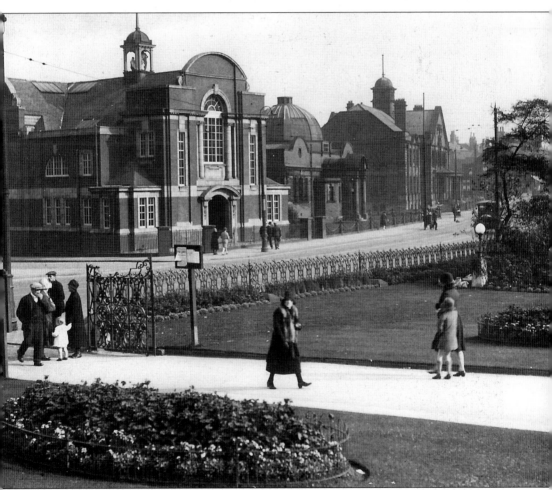

The entrance to the Park in 1939 with the Baptist Church, library and town hall in the background. These buildings form a trio, giving a pleasing appearance and contributing to the character of Farnworth.

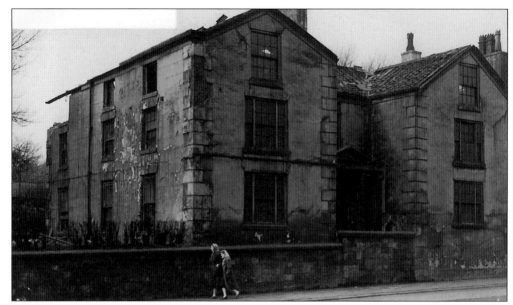

Birch Hall March 1953 shortly before demolition. The house stood at the centre of Bolton Road and Gladstone Road and was scheduled as a building of architectural and historical interest. The house had been empty since the death of the last tenant, Mr J. Smethhurst. In 1872 the building and land were sold for £10,000 and in 1893 it was purchased by the Council with a view to extending the park. (*Farnworth Journal*)

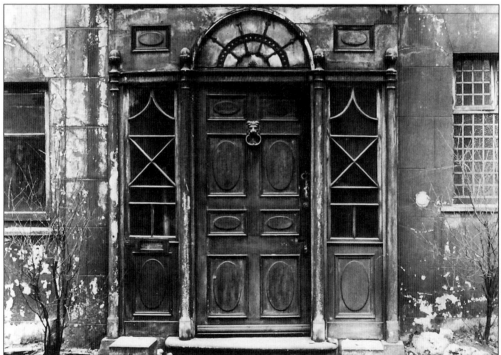

Antique furniture and oil paintings were auctioned in 1950. The Adam style doorway was to be preserved and kept in the Council yard for storage in the hope that one day a use would be found for it. Where is it now? (*Bolton Evening News*)

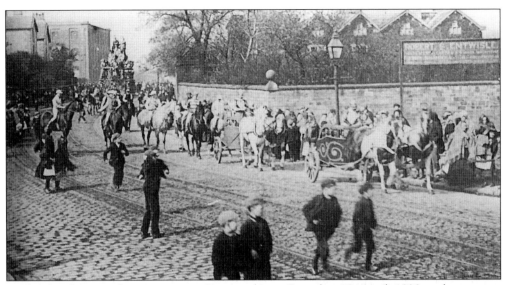

Lord John Sangers Circus came to Farnworth on Saturday 23 April 1898 and gave two performances on the Market Ground. There was a procession of lady and gentlemen equestrians, chargers, chariots and wild beasts at noon and for half an hour the principal streets were thronged with onlookers. It claimed to be the largest and grandest show on earth involving 250 horses and ponies, a large herd of elephants, camels, lions, numerous curiosities and freaks, racing tournaments, chariot races and an elephant football match with clowns. All the property and performers were on view in the procession which is just passing the spot where the library now stands with Birch House in the background. (J. Pickford)

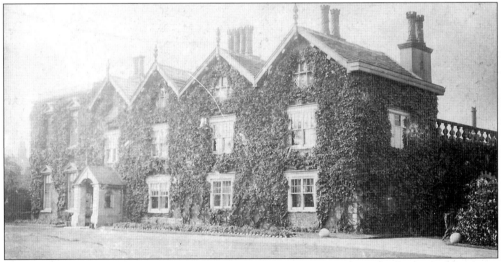

Birch House, 1895. The house was built in 1641 and stood where the Mead Garage is now. At various times it was occupied by distinguished families including John Bentley and his family and James Carlton, and Bentley Street and Carlton Street are evidence of this. In June 1897 the house was advertised as available to let and was described as follows; 'Desirable and commodious Family Mansion, standing in its own grounds, residence of the late Major Whittam JP containing Drawing, Dining and Smoke rooms, Library (Fine old oak book shelves, casings, etc.), Servants Hall, Kitchen, Pantry, seven Bedrooms, five Attics, Bath and WC., Coachhouse, Stables, and other outbuildings. Contents, 8,125 square yards.' (J. Pickford)

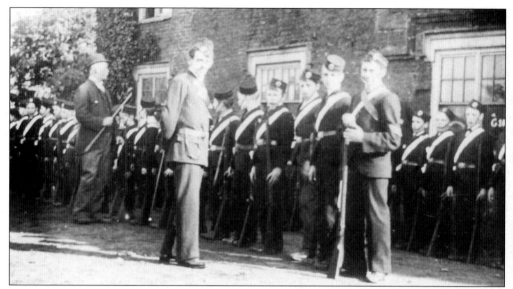

The Boys Brigade outside the house, c. 1896. The Boys Brigade was founded in 1887. According to the 1851 Census, The Hargreaves family lived there and the occupants were listed as George, head of household, born Westhoughton, Elizabeth, wife, b. Bamber Bridge; Elizabeth, daughter; Marie Lees, house servant; Sarah Simpson, house servant, b. Leyland; Catherine McGaw, house servant, born Penrith; and John Higham, groom and gardener, born Abram. (J. Pickford)

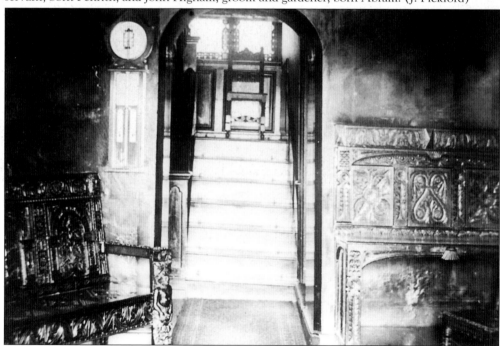

Interior, c. 1896. No one wanted to rent the house and in October 1897 the contents were auctioned including carved oak, old armour, the contents of the library and paintings by Sir Joshua Reynolds, Gainsborough and others. The executors of the late Major Whittam, who had employed 160 people in his cotton spinning enterprise, had given instructions to have the house itself put up for auction. (J. Pickford)

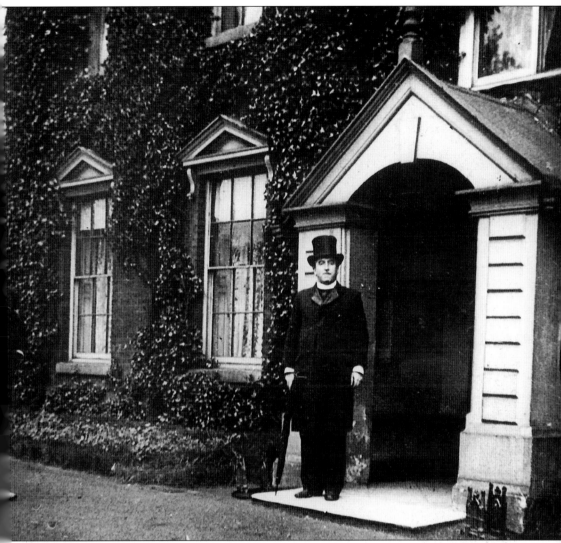

Clergyman outside Birch House, c. 1896. In December 1897 there was an auction of the
building materials and shrubs. The trees and shrubs were sold to Farnworth Council and the
grates and gas fittings were also sold. The *Farnworth Journal* lamented the sale of the house and
its destruction saying that no doubt it would be gone soon and cottages built on the land. This
did not happen until the early part of this century but the exact date of the demolition is not
known. (J. Pickford)

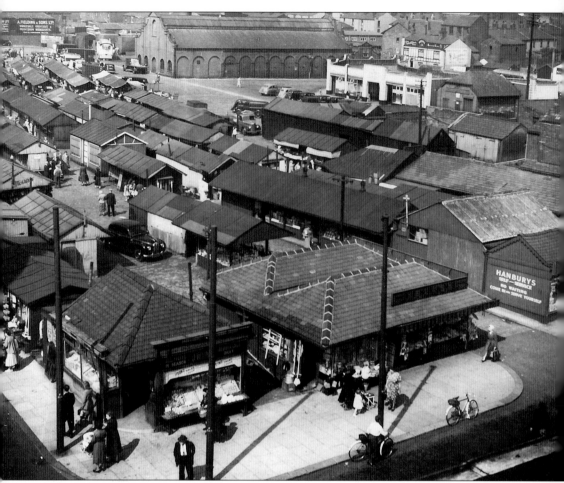

An aerial view of the Market Ground in 1930. In the background are the King Street Baths and the rear of the Market Arcade. In May 1926 The *Journal* reported that there is a market on Mondays, Fridays and Saturdays, when gentlemen from Cheetham Hill and Strangeways, together with a smattering of local folk and a goodly assemblage of loud voiced merchants from heaven knows where, make desperate efforts to separate Halshaw Moor from its week's wages. The owner of the loudest voice sells most. Most of the customers are women and a vendor of oilcloth calls them spectators. There is a man with a cure for every disease, just one box of his tablets curing a cough you could here at Moses Gate and getting a man back on his feet again and working a full week down the pit. 'By gum, he didn't know when he were well off ', said a voice. The traders from Manchester were a trifle subdued, for it was the week after the May 1926 Cup Final (Bolton Wanderers 1 - Manchester City 0)

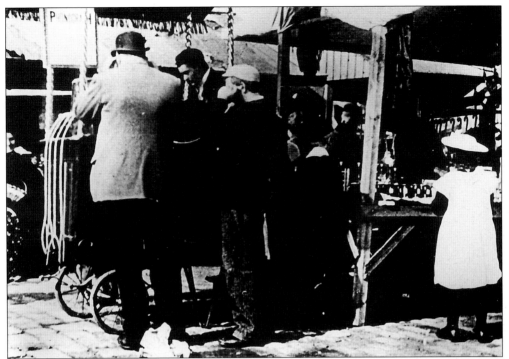

Market, c. 1890, listening to the Edison phonograph through ear pieces. Thomas Alva Edison invented the gramophone in 1878. The market was paved with setts in 1870 and sewered in Brackley Street and a public cab and hackney carriage standing was opened in that year on 31 December. (J. Pickford)

Farnworth Market, c. 1971. 'Now love, these sheets are like silk, fit for the Queen and yours for 50 pence a pair.' She shook her head. 'Well, I'll tell you what I'll do. You can have them for eight. Think of the luxury of slipping between these after bingo.' No answer. 'You're surely not waiting for me to ask less are you?' 'No, I'm waiting for our Sarah'.

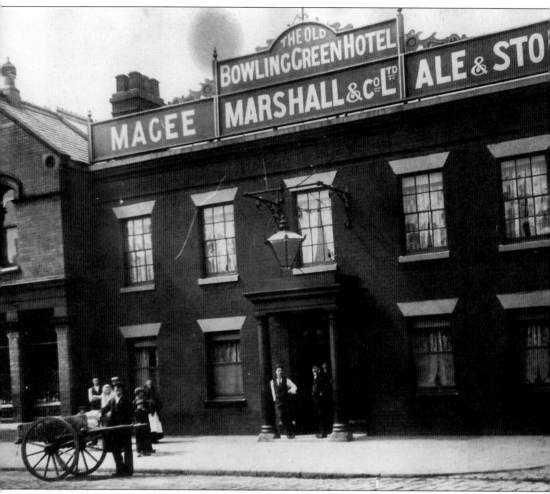

Bowling Green Hotel, Market Street, c. 1895. There was a bowling green in the early years of the hotel's existence but it was taken over to be used as part of Farnworth market in 1867. The building in the photograph dates from about 1851, when it was completely rebuilt. Many local organisations held meetings in the spacious club room and the hotel was a favourite place for their annual dinners. The hotel was a favourite mark for the start and finish of walking matches. It was demolished in 1967 and a new hotel was planned for the site which was opposite the Midland Bank, but it was redeveloped as shops and offices.

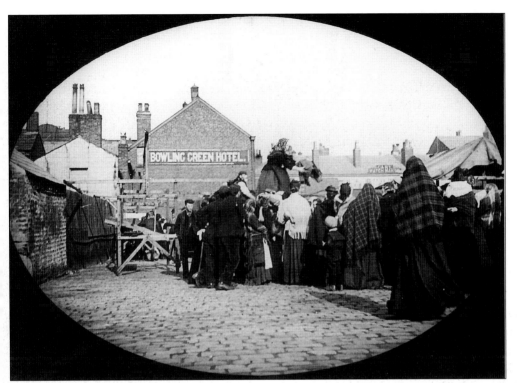

Market traders on the Market Ground at the rear of the hotel, c. 1900. 'Here y'are, ladies and gentlemen, a beautiful coat and vest, only needs a new lining, a few buttons, a bit of sewing round the cuffs and a good brushing. Scarcely been worn. The last owner wore it for Sunday best. He died on the way to church. Here's the three penny bit he had in his pocket for the collection. I'll throw that in for seven and six.' (J. Pickford)

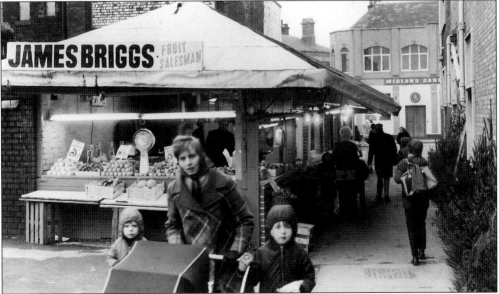

The market in 1965 with James Briggs shop at the rear of the Bowling Green Hotel. (*Farnworth Journal*)

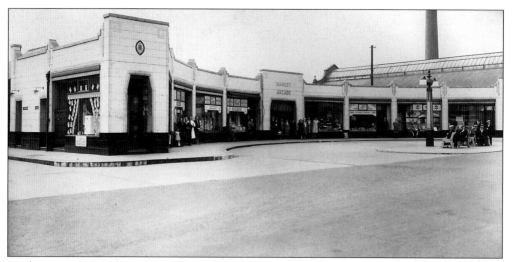

Market Arcade Buildings, King Street. These were officially opened on Saturday 26 October 1935. Within the buildings were fourteen single storey lock up shops which fronted on to King Street and the Market Ground at the rear.

The Arcade was designed to improve and increase trade and revitalise the centre. Access was provided to the market and there was a safety island at the front to form a bus station, which was the terminus for buses to and from the main housing areas. The arcade did not really attract the trade anticipated and was demolished in July 1970. (*Farnworth Journal*)

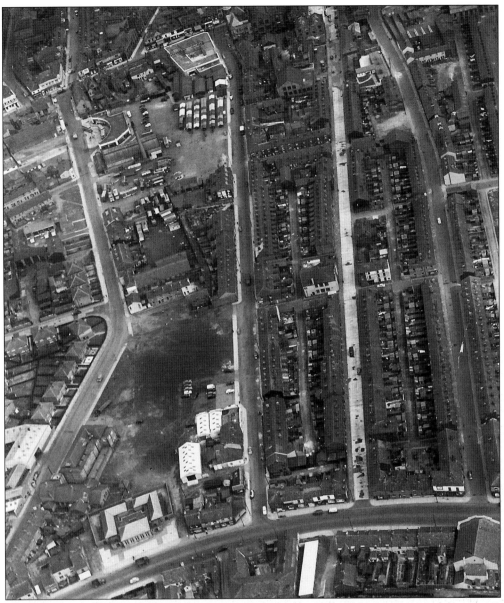

An aerial view of Albert Road, looking towards the market, July 1939.

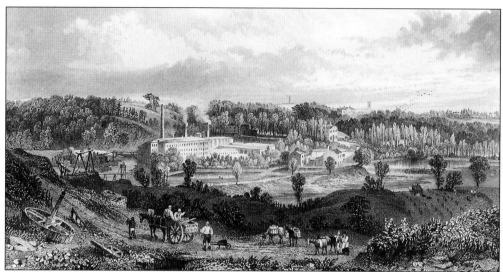

Farnworth Paper Mills, from an early engraving. Known as Farnworth Bridge Mill, and probably dating from the last decade of the seventeenth century, it came to be one of the largest in the country in the first half of the nineteenth century. It was Thomas Bonsor Crompton who made the mill famous in his lifetime, inventing the continuous drying process when he was only 26 and completely revolutionising the industry. He was the first to utilise cotton waste in paper manufacture and supplied paper for both the London and provincial press, later becoming the proprietor of the *Morning Post*. When he died in 1858 a contemporary described him as the 'founder of Farnworth', a distinction he shares with James Rothwell Barnes.

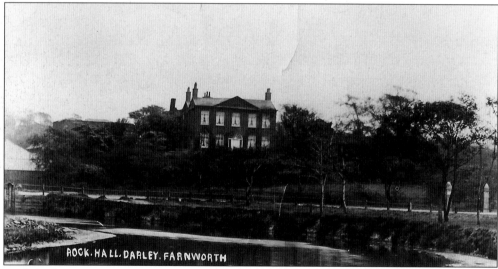

Rock Hall, c. 1920. The Hall was built by Thomas Bonsor Crompton's father, John, who was granted the lease in 1805. John reputedly never lived in the house as he died at about the time the house was completed. Later it was occupied by the managers of the paper mill. On Thomas Bonsor's death the mill passed to his nephew W. J. Rideout. After his death in 1876 the mills were offered for auction but it wasn't until 1894 that the place was let to J. B. Champion, Bleachers of Bury. The mill was demolished in 1972/3 and the only remaining visible signs of the once prosperous undertaking are Rock Hall, which is now the visitor centre in the Moses Gate Country Park, and the redesigned and landscaped Crompton's Lodges.

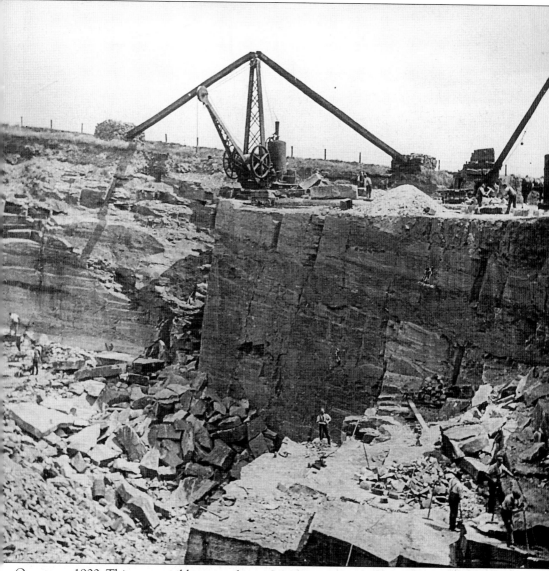

Quarry , c. 1900. This was possibly situated near Smethurst Lane, off Plodder Lane. In the 1871 Directory there is a stone merchant and quarry owner listed, named R. Bridge at Highfield Delph, Plodder Lane. (J. Pickford)

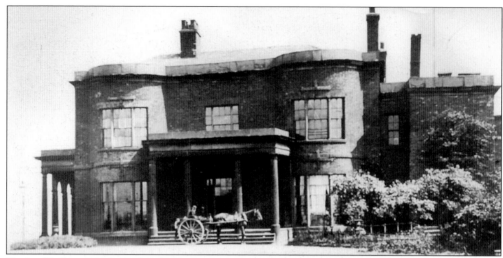

Darley Hall, c. 1890. Darley Hall stood in what is now known as Darley Park and was at one time a mansion of considerable importance, the estate extending from lower Darley to the top of Rawson Street. It was built by Benjamin Rawson, who was a chemical manufacturer and noted benefactor, in about 1806 and who lived there for many years. James Rothwell Barnes also lived there later and died at the Hall in 1849. Tenants after that were Captain Laws and William Hargreaves of Hick Hargreaves who left in 1873. The Hall was in use for social functions in the early years of this century and the estate was purchased by the Urban District Council in 1911 and used as the site for a bowling green, tennis courts, and a football pitch. The Hall itself was demolished in about 1914.

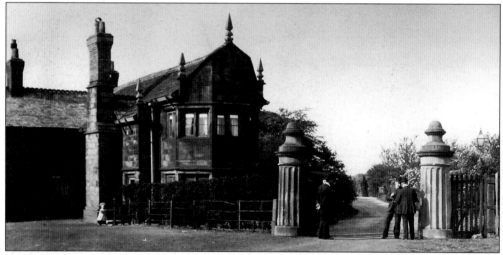

Entrance Lodge to Darley Hall, 1907. Dodie Smith, the author of *101 Dalmations*, was born in Whitefield in 1896 and later lived in Old Trafford, Manchester. In the first part of her autobiography, *Look Back With Love*, she describes how her mother's family used to live at Darley Old Hall and her Uncle Eddie (Furber), her mothers brother, used often to talk about the years they lived there. This house, though, from its description was not the one in the picture above and the account is from memory. Dodie Smith only went twice to Darley, first when she was about twelve when the house was to let, and again in 1930, when 'the house near the disused paper mill was occupied, with dilapidated washing outside and forlorn looking children playing'. Possibly it was Rock Hall.

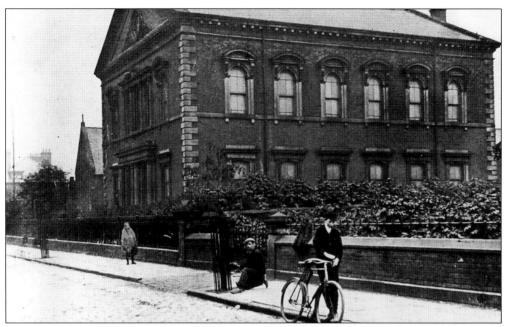

Wesley Chapel, Church Street, 1913. The cornerstone was laid on 9 July 1860 in the presence of 1,000 people and the chapel was opened on 24 October 1861. The church was demolished and the site is now a car park.

Education Offices in Rawson Street, c. 1960. The Director of Education from 1918 to 1948 was Mr Tyrer. Before 1944 Farnworth had its own Education Committee which was responsible for the service. After 1944 Education was the responsibility of the County Council and Mr Tyrer was also responsible for Kearsley and Little Lever. For many years Farnworth paid its teachers slightly more than elsewhere in order to attract better teachers. Mr Tyrer was succeeded by Mr E. E. Clarke. The building is now a private residential home.

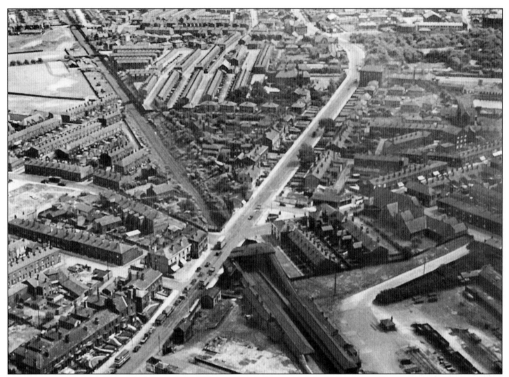

An aerial view of the railway and Moses gate, looking towards Farnworth in 1961.

Squeezebelly Entry about 1970. The apt and affectionate name for the bridge over the railway near Ash Street, with Farnworth Grammar School in the background.

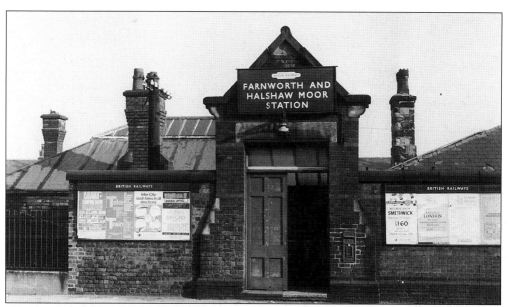

The entrance to Farnworth railway station. This station went under the name of Farnworth and Halshaw Moor, the other name by which Farnworth was known. The Manchester and Bolton Railway was opened on 29 May 1838 and Farnworth station was originally called Tunnel, after the Halshaw Moor tunnel on the Manchester side which is 290 yards long

Farnworth station. In its heyday it was a very impressive, well appointed station, a far cry from today's replacement which is merely a halt on the line. It was built to cater for the passengers that a thriving industrial centre, densely populated with numerous mills and factories, generated. The nearby Rawsons Arms Hotel was built on a similar scale to accommodate the many travelling representatives who visited the area, as well as music hall artistes appearing locally.

In 1957 Mr Molesworth was the Station Master. In the background is a poster advertising trips to the area's favourite destination - Blackpool illuminations - 'ask for train times and fares'.

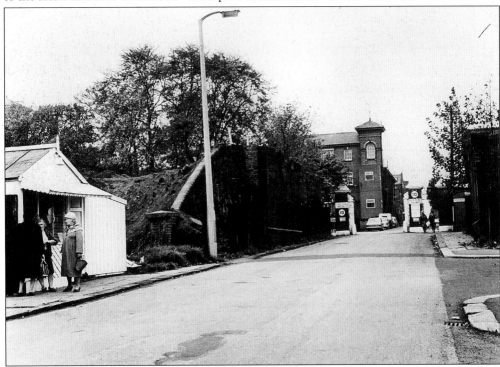

October 1969, Minerva Road leading to Townleys showing the old railway embankment and the gate post entrance to the hospital, since removed. (*Bolton Evening News*)

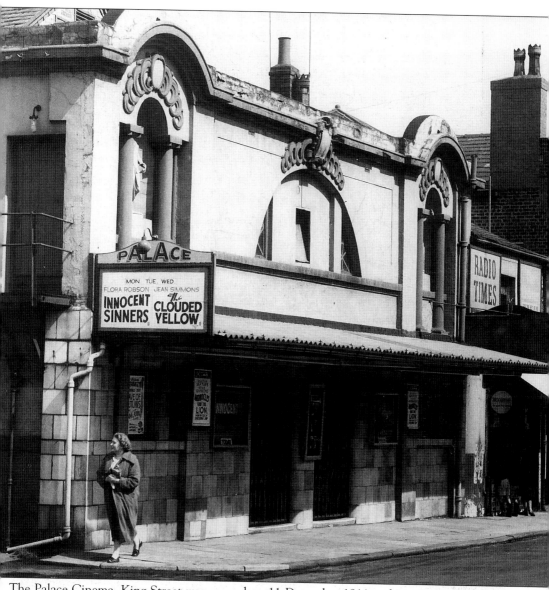

The Palace Cinema, King Street was opened on 11 December 1911 and was Farnworth's first purpose built cinema. It had 764 seats and the *Farnworth Journal* described it as having 'a generous allowance of room for those who occupy the 2d and 4d places, every comer having his own tip up seat, whilst the 6d seats covered in pegamoid, and the 9d ones in red velvet are luxurious. The opening exhibition of pictures was attended by almost all the local trades people and many of our public men. The films were the best that could be secured, a coloured one illustrating *The Siege of Calais*, a humorous one, a cowboy story and a trick picture. Mr Percival Entwistle of Moses Gate, charmed with his musical interludes on a grand piano.' The cinema closed on 8 November 1958 leaving three cinemas in Farnworth, the Hippodrome, the Savoy and the Ritz. The last film was Richard Widmark in *The Last Wagon* ('Nothing could stop the last wagon from coming through'). The Cinema made way for extensions to Mellings Bakery.

"SUNDAY"

Postcard advertisement, 1909.

Albert Modley appeared at the Ritz Bingo on 18 September 1971 when attempts were made to establish the old cinema as a bingo hall, a venture that only lasted for two and a half weeks. (*Farnworth Journal*)

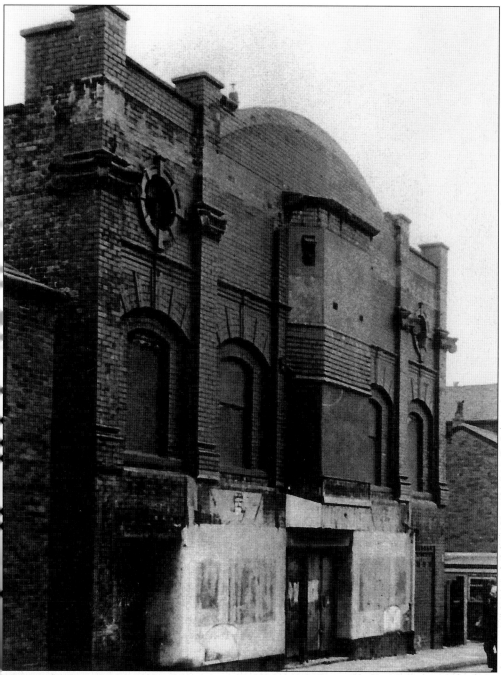

The derelict Ritz Cinema in Peel Street in 1979. Originally the Queen's Theatre it opened on Monday 17 April 1899 and was renamed The Ritz in 1927. It opened as a 'talkie' cinema on Whit Monday 1930 and was advertised as having the perfect talkie apparatus for miles, the Rolls Royce of installations. It was also the venue for the first production by the Farnworth Amateur Operatic and Dramatic Society who performed *Miss Hook of Holland* there in December 1930. It was renamed the ABC Farnworth in 1968, and later Studio One, showing as its final film *Get Carter* in 1971.

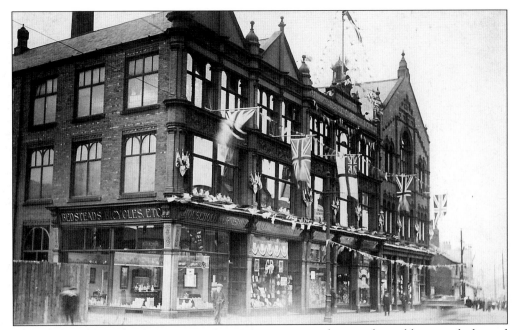

Farnworth and Kearsley Co-operative Society's main store, decorated possibly to mark the end of the First World War. The Market Street frontage of the Co-op, which comprised the new drapery store was opened on 24 July 1915 and was built on the site of the Ship Canal Inn. The other departments already adjoined the new store. 'Surrounded by chaste white walls, with beautifully polished mahogany counters and a grand staircase in the centre this new store might well be in London.' The architects were Bradshaw Gass and Hope and the building was described as French Renaissance in style.

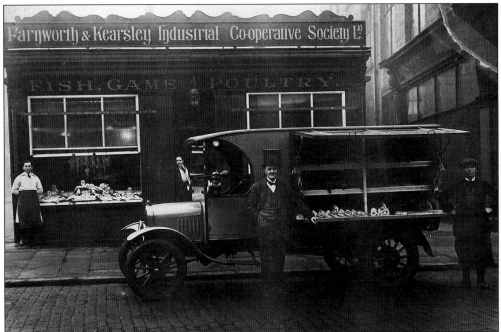

Delivery van, c. 1920.

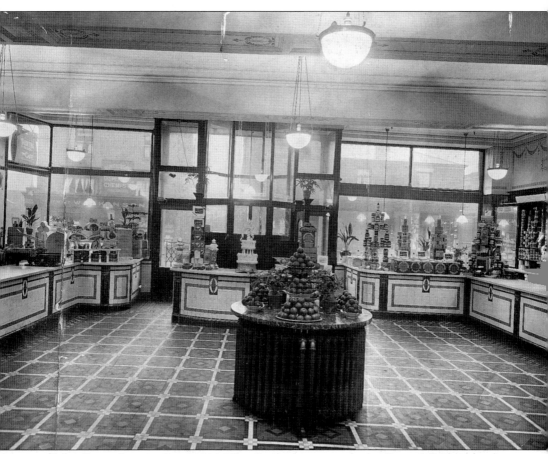

Interior of the Co-op Grocery Store 1920. The Co-operative stores were beautifully appointed and great care was taken with fixtures and fittings and the way that goods were displayed.

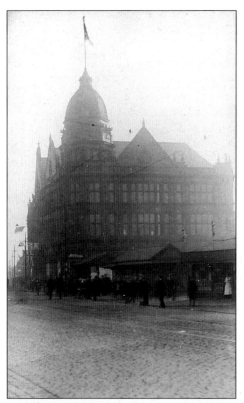

The Co-op was perhaps the most striking building in Farnworth but it was demolished in May 1985 to be replaced by a single storey open plan store. Some of the original brickwork was used to make the 'flower beds' on the site where it once stood in Victorian splendour.

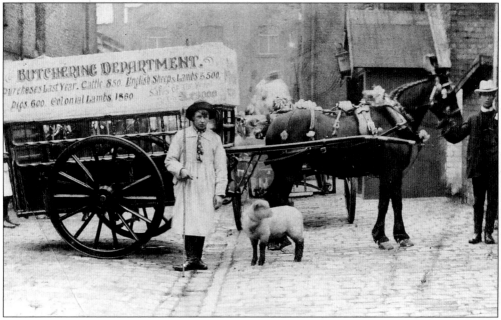

John Bennet of the Butchering Department, c. 1900. A sign says, 'Mayday purchases last year - Cattle 850, Sheep and Lambs 3,500, Pigs 600, Colonial Lambs 1,360. Total sales £23,000. Taskers Farm, comprising fifteen acres of freehold meadow land and buildings, was owned by the Society.

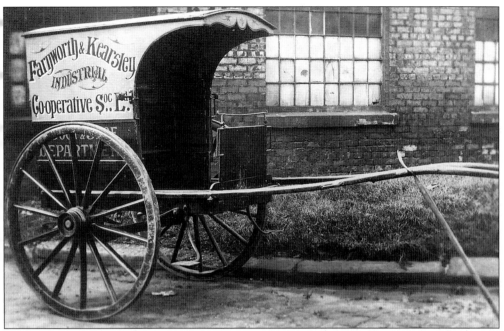

A horse-drawn trap for Co-op deliveries. In the early days of Co-op milk delivery a white horse called 'Old Dick' served the department for thirty years.

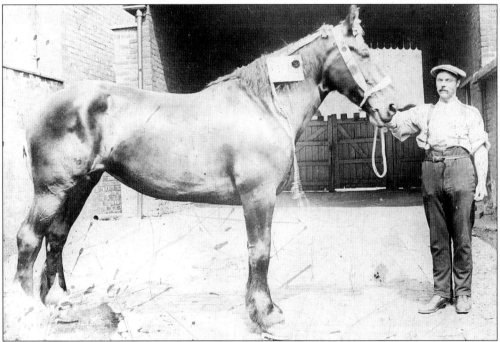

Horses were stabled at premises on the corner of Harrowby Street and Albert Road. In 1935 the Society had two prominent successes with horses at the Salford Pageant. 'Silver King' won the Davies 70 Guinea Cup, and 'Star' won a 400 day clock by taking second. Both horses were employed in the coal department business and were under the care of Mr Mills who looked after the Co-op horses for many years, winning awards with various horses.

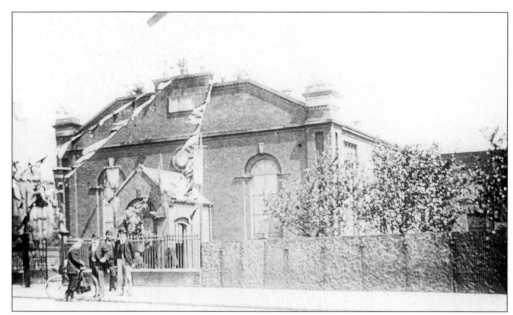

Holland's School, Market Street, decorated for Queen Victoria's Jubilee, June 1897. Roger Holland founded a Sunday School in 1808 for children of all denominations in Farnworth and Kearsley and the new premises in Market Street were built in 1868. It was very successful , a library was established and evening classes began. It continued in this way for many years but attendances eventually began to fall. James Ratcliffe, the Farnworth vet. was Superintendent for many years and by his efforts and enthusiasm kept this independent school going. In the 1980s it finally closed and is now a nursing home. (J. Pickford)

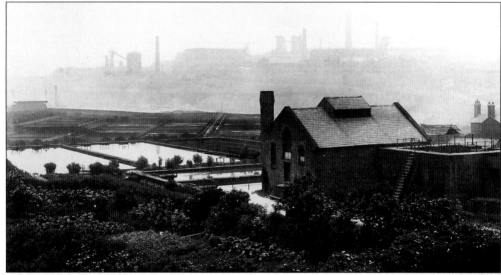

Hall Lane Sewage Works, 1910. These were situated near the bridge over the River Croal. In 1914 the Council proudly stated that 'no chemicals were used in the treatment, the method adopted, shortly stated, being deposition or sedimentation of the suspended solids in large tanks, followed by the purifying agency of nitrifying organisms in the filter beds'. The site of the nearby Bolton Hacken Lane works is now used for football pitches belonging to Bolton Lads and Girls Club.

The Toll House, 124 Bradford Road used to be known as Wash Lane Gate House and was Farnworth's last toll house, in use until 1920. There was a gate adjacent to it and all vehicles passing along the road were charged 1 penny per wheel which also paid for the return journey. Cows and other animals cost their owners a half-penny each but farmers, pedestrians, cyclists, doctors and ambulances were allowed to use the road free of charge. Average takings were five shillings a day. Toll charges were abolished in September 1925 and the gate was removed in the 1950s.

Wesleyan Chapel, New Bury. This chapel was on Church Street, New Bury and was opened on 18 January 1905.

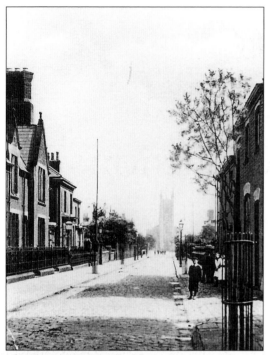

Church Street, with Rose Cottage further down on the left, c. 1907.

Rose Cottage, Church Street in 1966. Built in 1843 it was occupied until 1893 by Mr Simeon Dyson and his family. Simeon Dyson was the son of the Revd Joseph Dyson, the first Minister of the Farnworth Congregational Church, from 1813 to 1855 and played an important part in its history and development. Simeon Dyson wrote about the cottage in his *Local Notes and Reminiscences of Farnworth* (1894) describing how, 'in 1845, the garden had so many roses they collected them in a clothes basket and in 1848 fifty-seven varieties of dahlia were grown, but now at the time of writing even the commonest and hardiest white rose will not live in the same garden'.

# Six
# Events and Special Occasions

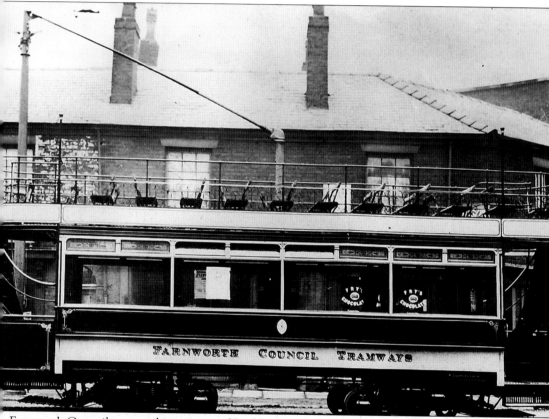

Farnworth Council tram at the junction of Buckley Lane and Albert Road, 1905. The Council's trams, numbered one to eight, were painted bright chocolate and lined with gold, with the coat of arms on the side. On the lower, yellow painted panels was 'Farnworth Council Tramways' with the Town Clerk's name in smaller letters. The inside seats were of light oak laths stained to match the woodwork and curtains of red rep gave an air of warmth. Outside passengers were safeguarded by a neat scroll-work screen, but no protection was afforded the driver and conductor. The cars carried thirty passengers inside and thirty six outside. The undertaking was leased to the South Lancashire Tramways Company in 1906. The tramway was divided into three half penny stages - Glynne Street, Longcauseway and The Blackhorse. The through charge was a penny with concessionary fares for workmen at specified times.

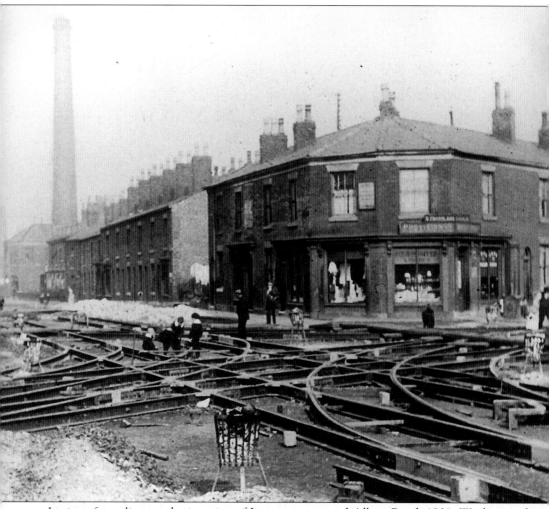

Laying of tramlines at the junction of Longcauseway and Albert Road, 1901. Work started in May along Egerton Street, Albert Road and Longcauseway and was completed in October. The building on the far left on Albert Road is the Farnworth Electricity Works. In the *Farnworth Journal* 9 August 1901 a complaint was made that the contractor for the new tramways had allowed his horses and carts to go across the footpath in Longcauseway and Albert Road and road traffic had followed, owing to his carts blocking the road. Other traffic could not wait to pass but drew over the footpath damaging 394 flags and breaking 73. It was therefore decided to stop all traffic in Albert Road during the laying of the tramway track. (J. Pickford)

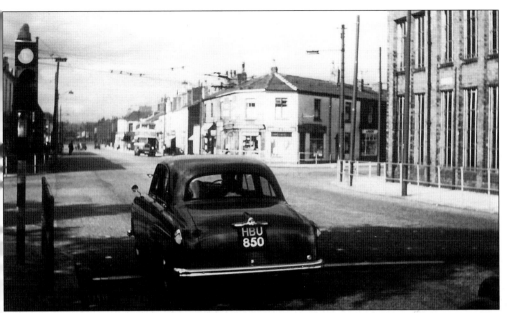

The same junction in 1957. The chimney shown in the picture opposite was part of the Electricity Works and had gone by this time.

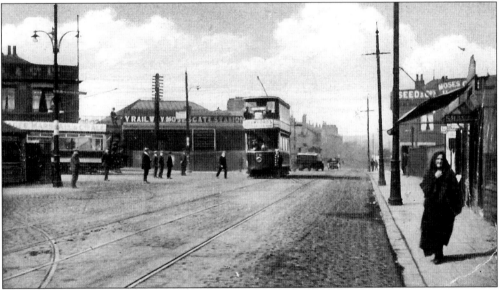

The date on this postcard view is Saturday 20 August 1914 and it was sent by Polly Ward of Bolton Road, Kearsley to Lizzie Rostron at the Britannia Hotel, Lomax Street, Rochdale. It reads, 'Dear Lizzie, Got home about half past ten. There was 5,000 troops past our house this morning about 7.30. Oh it was a sight, your pa said something about the troops but could not catch what it was.' The war had made little impact on Farnworth then, being only two weeks old when on that Saturday morning the Loyal North Lancashire Regiment of Territorials came through town from Manchester having set off from Salford at 5am. The troops were accompanied by baggage wagons, military cyclists, buglers, drummers and a fife band. They rested by the library and park where residents served them tea and gave them cigarettes. The troops complained of the difficulties of marching on the granite setts on the road.

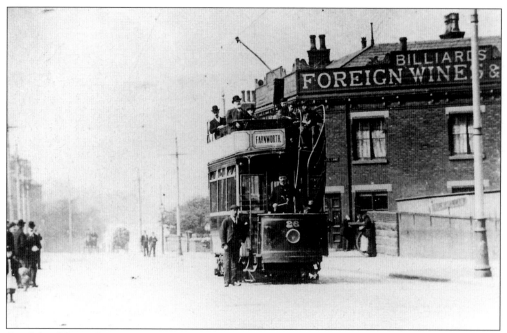

Car 26 at Moses Gate, c. 1902. Horse trams operated from the late 1870s, the last one running on 1 January 1900. Electric trams ran from 2 January 1900 to Moses Gate but Farnworth was not electrified until 1902. (Transport Museum)

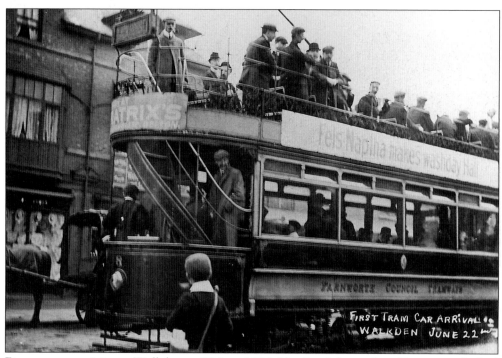

First tram car arriving at Walkden on 22 June 1906. The South Lancashire Tramways who had taken over the Farnworth system in 1906 extended the line to Walkden thus enabling Farnworth to be connected to other systems, something it was unable to do on its own.

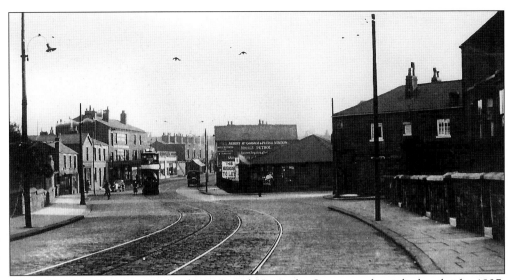

Albert Road with a tram in the distance and Harrowby Street on the right hand side, 1937. After 1926 South Lancashire Tramways transferred part of its responsibilities to Bolton Corporation. By now the ex-Farnworth cars had been given covered upper saloons and were being used by the SLT on the Bolton to Lowton via Leigh route. In 1933 eight of these cars were purchased by Bolton who used them on the Black Horse route until 1944 when the last tram ran.

Dixon Green Congregational Church on a charabanc outing. Thomas Raynor is in the centre. ' A charabanc trip was more than an event, it was in the days when pleasures were not easily come by, something which made people eagerly cross off the days on the Co-op almanac. The "chara" conveyed all classes and creeds slowly but safely and resembled a giant centipede on wheels. Occasionally when a charabanc proprietor developed an attack of wanderlust he would organise a trip to the Shrewsbury Flower Show. This wasn't an outing - it was an adventure into the unknown, in which only the strong rugged type of Empire builders would be interested. Stores would be laid in overnight and crates of beer and tins of petrol would be carefully stacked.' (*The Clatter of Clogs* by Paul Fletcher, Clog-Lamp Press, 1972)

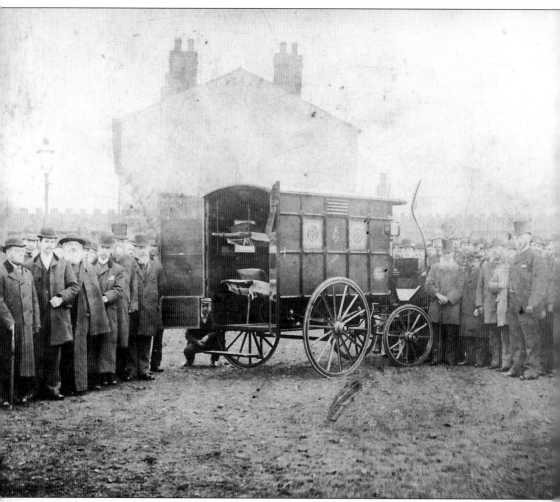

Farnworth's first ambulance being presented to the inhabitants of Farnworth by Superintendent Leeming of the Lancashire Constabulary, on the drill ground, Church Street in March 1895. Inside were two stretchers covered with India rubber sheets and one of those had detachable rubber wheels so that it could be taken into a room, mill or workshop where the carriage could not go. It was built at a cost of £100, the amount being raised by a football match played on 12 December 1894 between the Police and Farnworth Wednesday Clubs. Mr N. Nicholson, Chairman of the Urban Council, acknowledging the gift said, 'It seemed appropriate that footballers should raise the money needed since whenever he had attended a football contest he had been surprised to find that ambulance carriages were not required more often'.

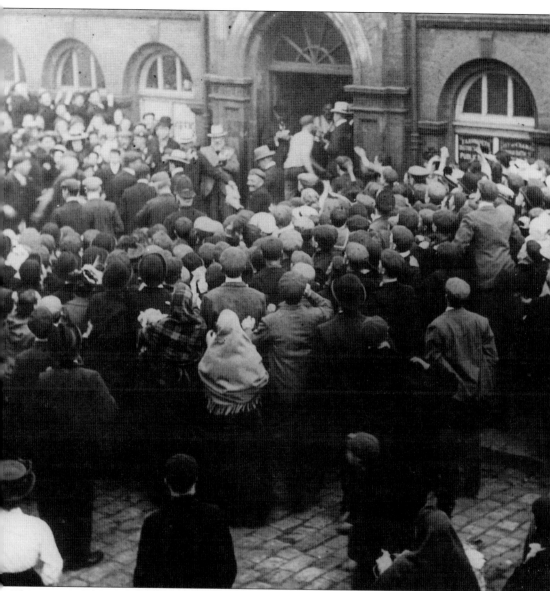

The opening of the public baths in King Street took place on Saturday 29 April 1893 at 3.30 p.m. There was a grand swimming gala to celebrate the opening and this photograph shows that the walking match in the next photograph finished there, the same officials being clearly visible. Theresa Johnson of London, lady champion of the world, gave a display of ornamental swimming. The baths were provided by public subscription, Mrs Almond giving £1,000 towards the original cost of £3,200. They consisted of a plunge bath, 75ft by 30ft, a wash bath and shower and twelve slipper baths. Charges were 6d for a slipper bath, first class with two towels and 3d for a plunge bath, including towel (2d without). Loan of drawers was a halfpenny per pair and 450 pairs of bathing drawers were ordered from Cunninghams of Dunfermline. The plunge bath was reserved for ladies on Mondays from 6am to 6pm but on the first Monday only three ladies used the baths. One of the bath's managers in the 1930s, Mr Albert Cunliffe, invented a scum remover, the first to be used in England, guaranteeing clean water. (J. Pickford)

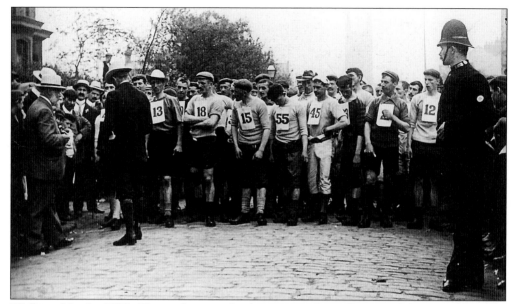

Walking Match, 1893. These often involved miners and usually started from The Bowling Green Hotel during Farnworth Wakes. This match started in Church Street outside the Conservative Club and was part of the celebrations for the opening of the baths, so possibly the race was followed by a swimming contest. (J. Pickford)

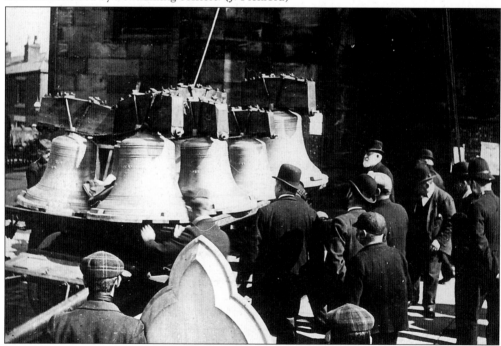

St. Johns Church Bells, 1899. These are the second set of bells arriving at the church. The first set were rung for the last time on Sunday 22 January 1899. When the first peal was brought to the church it was decked with evergreens and preceded by a band. On this occasion it was filled with beer. The bells, which cost £540, were replaced by mechanical ringing in 1976. (J. Pickford)

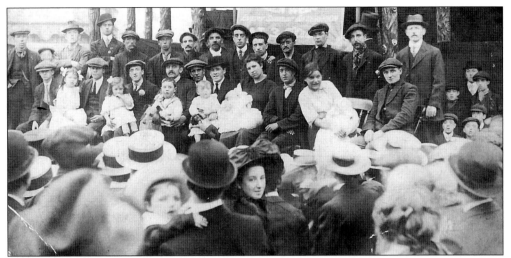

Farnworth wakes service on the main roundabout, 1910. The wakes events first took place in September 1827 and probably celebrated the anniversary of the opening of the Parish Church. In the early days the wakes were more of a village fair with much feasting and revelry. Attractions at the fair in September 1873 included Gorton's Albert Theatre, Richards' Ghost Show, Peace's Models, Makin's Phantascope, Greenwood's Temple of Magic and Allan's steam horses and velocipedes. Regulations against stall gambling were rigidly enforced by the police.

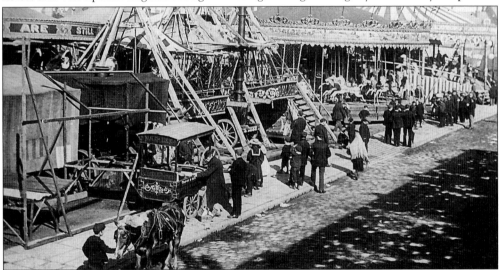

Farnworth Wakes, c. 1898. The *Journal* of 17 September 1898 recorded that 'the Market Ground in Brackley Street has been extended a little during the summer by the pulling down of some cottages on the Albert Road side of the baths, and the extra space is made use of by Mr Farnworth, the market inspector who has let it to the proprietors of a small circus. The only other show is an exhibition of animated photographs and the rest of the paraphernalia in the market is much as in past years, a set of gondolas replacing a razzle dazzle, and a set of ostriches, the old fashioned bicycles. Plenty of room has been left for sightseers and with the absence of the objectionable swinging boats, there is little fear of accidents occurring. With the object of keeping the children from the fairground there are attractions at the various Sunday schools.' Afterwards it reported that there were no accidents and rent received from the show people totalled £193 14s 7d. (J. Pickford)

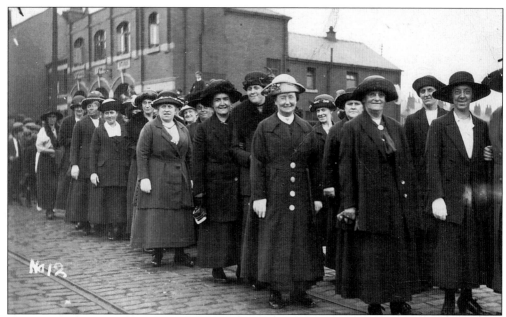

Dixon Green Congregationalists on Albert Road outside the fire station, going towards Longcauseway 1920. Walking days have been a traditional display of religious faith at Whitsuntide and have taken place in Farnworth from 1842. As more churches and schools were established they each held independent walks of their own, followed by 'treats' for children.

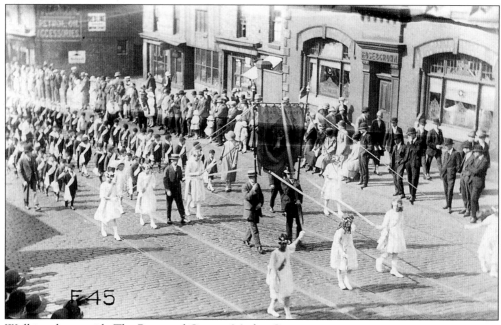

Walking day outside The Rose and Crown, Market Street.

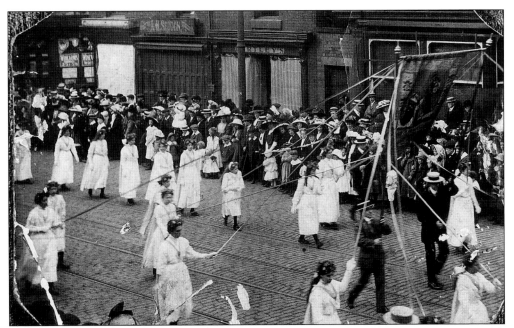

Aunts and Uncles nipped from the pavements to pass pennies into little hands. Countless bands played and often contested the route with each other.

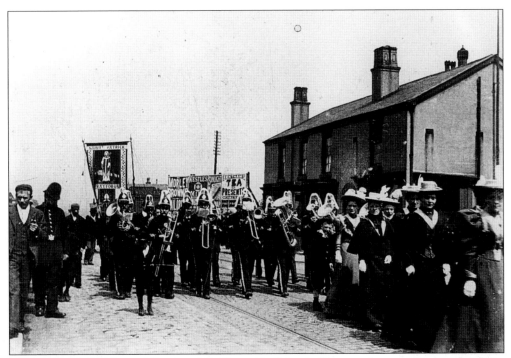

Whit Friday 1896, Barnes' Band and St Gregory's School. This was the year Farnworth saw its first united procession. By 1921 there were so many walkers at Farnworth that the processions were divided into sections A and B, each taking its own route.

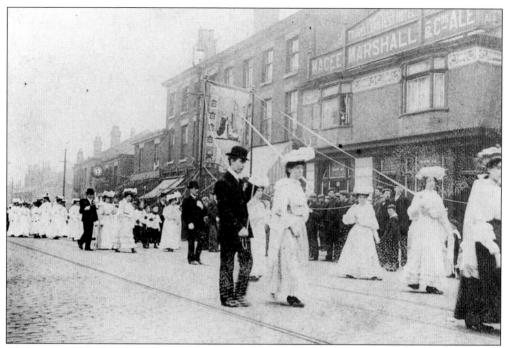

Walking Day, Market Street. In recent years the big processions became only memories as fewer walked and fewer bothered to line the kerbs.

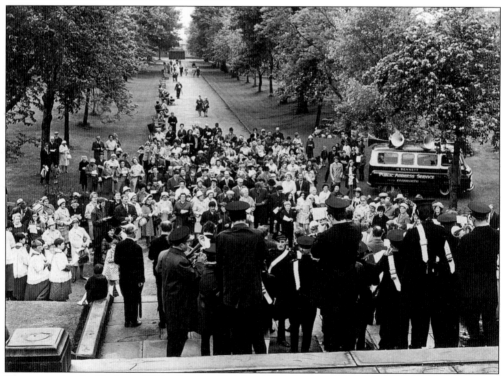

The scene in the Park on Whit Sunday 30 May 1971 during the United Service organised by the Farnworth District Council of Churches

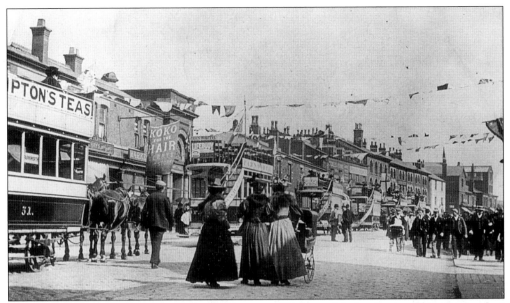

A procession of horse-drawn trams for the Diamond Jubilee in Market Street, with the National Westminster Bank in the background. Note the sign next door which says 'Koko For The Hair'. The street decorations in Farnworth would not have disgraced a larger town and it was a celebration which was enjoyed by everyone. Collieries, mills and workshops were all silent for two days and the weather was good. 700 old folks were given tea in the Moor Hall and at the Workhouse there were sports and extra food. (J. Pickford)

Queen Victoria's Diamond Jubilee, Tuesday 22 June 1897. There was a big bonfire on the Recreation Ground, Albert Road, which was lit at 10pm. Farnworthians returned here from Bolton where they had visited Queens Park to see the fireworks and the street illuminations. The crowd lingered until daybreak and there was plenty of entertainment of a rough but good humoured sort with a concertina or two being produced and open air dancing. (J. Pickford)

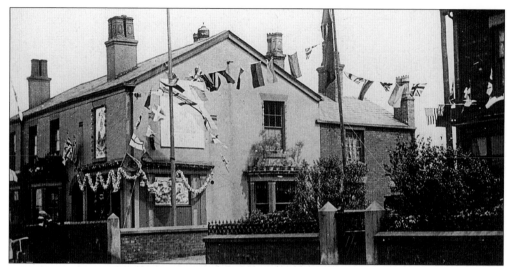

Moses Gate decorated for Royalty. The *Journal* reported, 'George IV and Queen Mary visited Farnworth on 12 July 1913 on their tour of Lancashire, travelling from Moses Gate Station to Longcauseway, a distance of less than a mile. The streets were decorated, bunting was flying from humble cottage windows and flags waved from the staffs of all the mills and workshops. Farnworth, though healthy and well situated is hardly beautiful but it presented its very best face on Saturday.' The Royal Party did not stop in the town despite a request to lay a foundation stone because no stops were made in districts with less status than a Borough. (J. Pickford)

Coronation Cottage, Longcauseway, decorated for the Coronation of Edward and Alexandra in 1902. The cottage earned a reputation for decoration during Queen Victoria's Diamond Jubilee. 'The ornamentations at the triumphal arch in front of Mr Nuttall's cottage in Longcauseway were quite ornate.' The cottage is still there on the left hand side going towards The Black Horse. Farnworth Park was also decorated for the Coronation which should have taken place on Tuesday 26 June 1902. The King, however, was ill and the Coronation was delayed until 9 August 1902. Celebrations still took place in June but the day was not a holiday despite the King's wish. The flower bed had the Prince of Wales feathers as a centre piece and there was a special band concert in the evening. (J. Pickford)

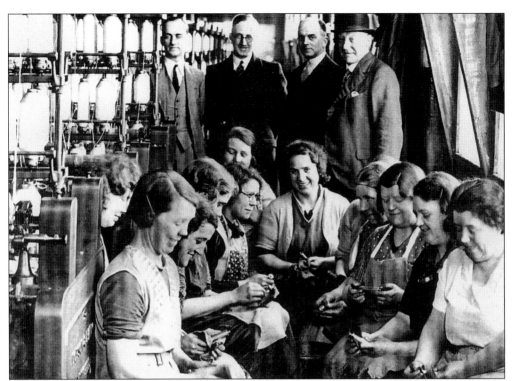

Century Ring Spinning Company's Mill in George Street, New Bury in December 1937. Employees are shown engaged in the work of preparation and cleaning prior to reopening after being closed for six years during the depression which overtook the cotton industry. No fewer than fourteen mills in the Farnworth area closed at this time. Before 1930 the mill employed more than 500 people and officials in 1937 were inundated with applications for work. (*Farnworth Journal*)

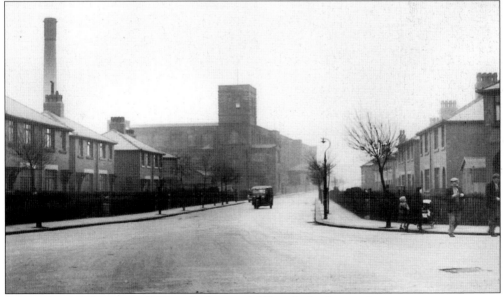

George Street, New Bury, 1937, with Century Mill in the background.

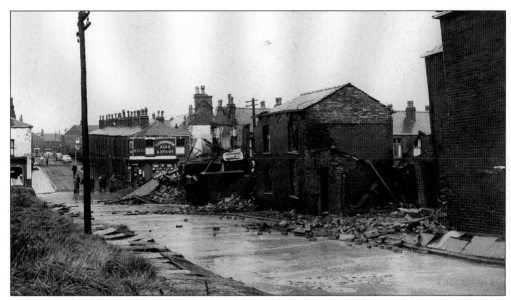

Fylde Street, 12 September 1957. Twelve houses were either completely or partially collapsed or made uninhabitable by subsidence when a sewer collapsed suddenly in the early morning, following prolonged heavy rain. It was the most dramatic news story of the century as far as Farnworth was concerned. The Mayor opened a distress fund and the story made news all over the world. Hylda Baker did a charity concert and £2,182 was raised at a concert at The Ritz with Shiela Buxton and George Martin. There was a collection at the Wanderers v Arsenal game on 5 October.

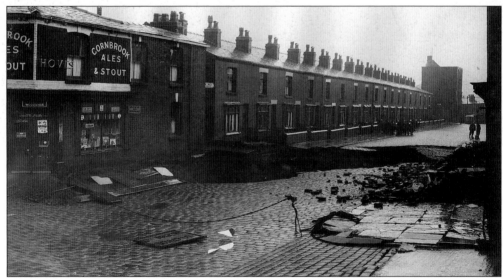

It was 7.10 am when a small hole appeared in Fylde Street near its junction with Hall Street. Severe ground movements spread rapidly along Fylde Street and by evening, when subsidence had virtually stopped, a crater 120 feet long, 18 feet wide and 20 feet deep had formed. Over 400 people from 121 homes had to be temporarily evacuated and 19 houses damaged beyond repair were subsequently demolished. Starcliffe Methodist Church was one of the rehabilitation centres used. Some of the possessions from the collapsing houses were put in the outdoor licence house of Mrs Doris Hague, 111 Hall Lane, on the corner of Hall Lane and Fylde Street.

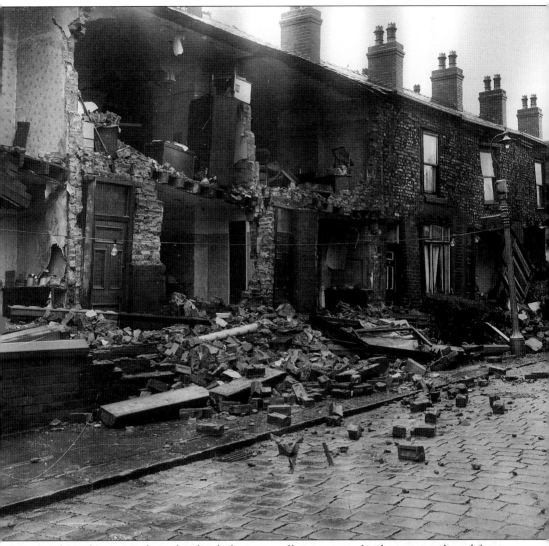

Doors and windows gape from drunkenly leaning walls in one twelve house stretch and front walls have fallen out to lie in piles of debris, exposing rooms still filled with belongings. Wardrobes and other bedroom furniture lean from the upper storeys and some lie splintered in the debris below. In a wardrobe in the picture was a wedding dress in readiness for the following Saturday. It had to remain where it was until well after the ceremony and 'something borrowed' worn instead. Council homes were allocated to those families who had to be rehoused and each family was given £50 immediately and £150 in vouchers for necessities. Miraculously, no one was either killed or injured but many people lost not only their homes but their livelihood as well. Many small shops and business properties were considered unsafe. As late as November 1960 a house which was evacuated during the disaster, collapsed during high winds.

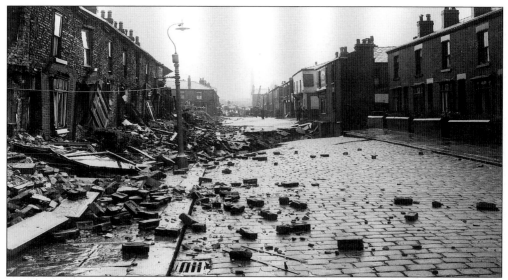

Another view of the crater. The cause of the sewer collapse was ground water movement and the fact that the sewer, built in 1867, was laid on silt, not clay. It was recommended that new main sewers for the town were constructed and work began on 1 September 1959 and was completed on 10 July 1961.

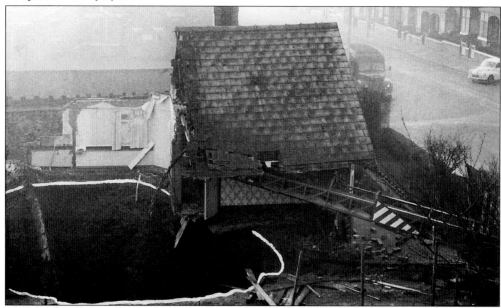

Worsley Road, Farnworth 23 January 1964 and all that remains of the bricks and mortar that once was the bungalow belonging to the McIvor family. The two back bedrooms disappeared to the bottom of the disused Stonehill Pit shaft, last used sixty years ago, which opened up a depth of 954 feet. Miner Mr William McIvor and his wife Susannah dashed from the bungalow only seconds before. The family were told by the National Coal Board that their mortgage would be paid off and they would receive what they had paid out for their home already as well as other compensation. The NCB poured 1,500 tons of rubble into the shaft but it reopened again on 29 December 1964 when a crater 30 feet wide and 20 feet deep appeared on the drive of Mr and Mrs Slater's home next door. (*Farnworth Journal*)

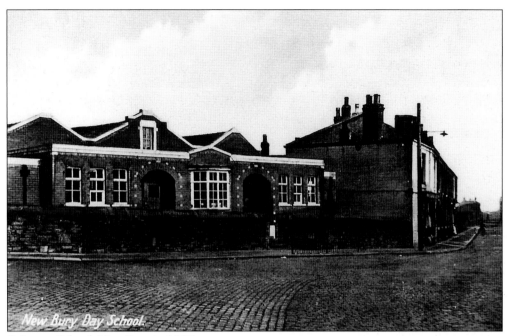

St James School, New Bury in 1907.

St James Junior School was built in 1834 and added to at later periods but by the 1920s was in a dilapidated condition. In 1930 the junior school was entirely rebuilt and the infants' school remodelled at a cost of £5,000. A new school was built in 1990 and the old school opened as a community centre in 1991.

H.R.H. Duke of Edinburgh officially opened the pavilion and the running track at the Harper Green Playing Fields on 5 July 1963. The total cost was £23,000 with grants of £4,500 being obtained from the Butlin Holiday Campers Fund and the National Playing Fields Association. In the programme it stated that 'it hopes in years to come we shall produce more athletes of the calibre of John Boulter who is now achieving national fame at Oxford University.' John was the son of Tom Boulter, the Farnworth Librarian (see page 20). He went on to run for Great Britain in the Olympic and Commonwealth Games, reaching the semi-finals of the 800 metres at the Tokyo Olympics in 1964. He is now a vice-president for Reebok which has its offices in Boston but its origins were in Bolton 100 years ago. (*Farnworth Journal*)

Opposite: Harper Green playing fields and, inset, Tommy Banks who was a pupil at Harper Green over fifty years ago. Tommy, born in 1929, and Ralph, born in 1920, were footballing brothers born and bred in Farnworth. Both were full backs and wore the number three shirt and both played for Bolton Wanderers. Ralph made his last first team appearance for Wanderers in the 1953 FA Cup Final and Tommy took over his position, collecting a cup winners medal in 1958 and played six times for England. On retirement he returned to work as a builder and helped build an extension to the school. His achievements were immortalised in a brilliant musical called *The Tommy Banks Story*, devised and performed by the school in July 1994.

The original Harper Green playing fields in February 1941 being ploughed up as part of the grow more food campaign.

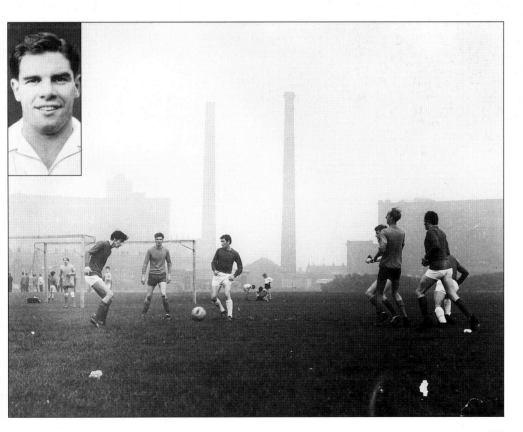

From Wembley to Farnworth, 3 May 1953. Bolton Wanderers Cup Final team at Farnworth where they were greeted by more than 10,000 people, after losing 4-3 to Blackpool in the 'Matthews Final'. Mounted police stand guard on the pavement at the entrance to the Town Hall as the Wanderers' coach comes to a stop. The team was welcomed on the Town Hall steps by the Mayor of Farnworth, Councillor R. Matthews. Captain Willie Moir, addressing the crowd said 'we are very very sorry we didn't bring back the cup for you but ten men against eleven is just a bit too much', a reference to Eric Bell's injury after eighteen minutes of the game (no substitutes allowed in those days). Prominent among the players are (left to right) Hanson, Lofthouse, Hassall, Moir, Wheeler and Barrass. A few minutes earlier the coach had stopped at Kearsley Town Hall where another big crowd saw the Chairman of the Council (Councillor J. Eckersley) climb into the vehicle to congratulate the gallant losers. Five years later the scenes were to be repeated but this time ' it were definitely Wanderers fer't coop!' (*Bolton Evening News*)

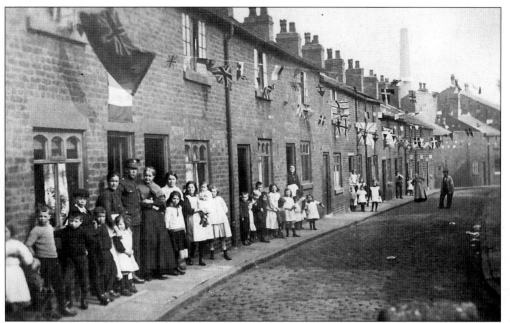

Vickers Row, 1918 and the scene of a homecoming after The First World War. It is probably that of Robert or Wilfred Pennington of number 30. They both worked at Lord Ellesmere's Brackley Pit before enlisting. Both were wounded, coming home before returning again to the front where Wilfred was taken prisoner. The sign for Vickers Row is still visible today on the side of the Canary Public House on Plodder Lane but the houses are no longer there. The Canary was formerly known as The Kings Arms but changed to its present name through popular usage of the miners who frequented it.

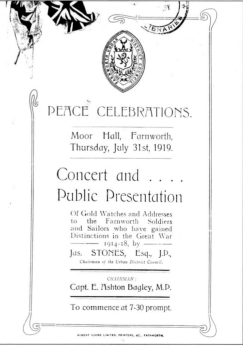

Peace Celebrations took place on July 13 1919. Eighty four sailors and soldiers who gained distinction during the war were each presented with a gold watch and a framed illuminated address. Bolton Museum now have the watch that was presented to Driver Norman Porritt who lived at 8, Moss Street. He was awarded the Meritorious Service Medal for gallant conduct.

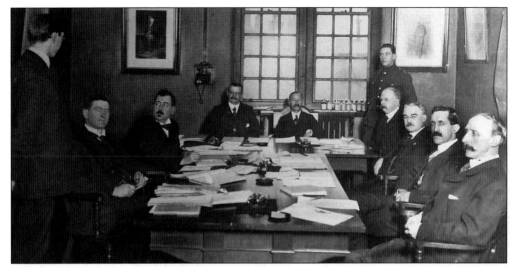

Farnworth's Local Tribunal in February 1916. Before March 1916 local tribunals, usually consisting of five Councillors, considered whether men should be exempted from service in the First World War. No one under nineteen would be called and there were four grounds for exemption; if they did work in the national interest, if enlisting would cause serious domestic or business hardship, poor health, or conscientious objection. After March the age was reduced to eighteen and very soon it became truly National Service with compulsion strictly applied and exemptions few. Pictured sitting, left to right: Mr W.Hargraves, Mr J.H. Hall (representative of the War Office), Mr W. Tyldsley (clerk), Mr J. Stones (chairman), Mr T. Stanley, Mr J. Kenyon, Mr J. Walsh, Mr J.E. Prestwich. (*Farnworth Journal*)

Certificate sent to relatives of men killed in the First World War.

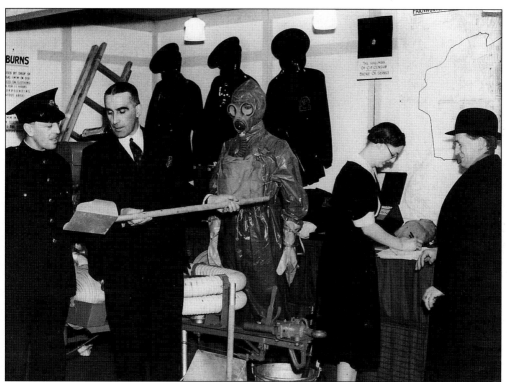

Civil Defence display, Town Hall 1939. There were no civilian casualties in Farnworth. The special book prepared to list the town's civilian dead remained empty and is now in Bolton Archives. (*Farnworth Journal*)

## BOROUGH OF FARNWORTH.

### HOW TO GET HELP
#### AFTER
### AIR RAID DAMAGE.

**Food and Rest Centres** provide temporary shelter for those whose houses are uninhabitable and who have not gone to friends or relatives.

**Injury Allowances.** For persons of 15 years of age and over, medically certified incapable of work due to injuries sustained in air-raids.

**Compensation.** Immediate help for immediate needs: loss of clothes, furniture, tools, etc. made good in certain circumstances.

#### PAID THROUGH THE ASSISTANCE BOARD

**Pensions** for Widows and Dependent Relatives of workers and Civil Defence Volunteers who are killed or die from their injuries are granted in certain circumstances.

#### PAID BY THE MINISTRY OF PENSIONS

**Damaged Houses.** First-aid repairs to make them wind and weather tight.

#### DONE FREE BY THE LOCAL AUTHORITY

**Removals or Storage of Furniture** from damaged houses.

**Rehousing and Billeting.**

#### HELP CAN BE GIVEN BY THE LOCAL AUTHORITY

**Lost** gas masks, identity cards, food ration books, unemployment insurance books, health insurance cards, pensions books, etc. are replaced.

#### HELP AND INFORMATION ABOUT ALL THESE SERVICES IS GIVEN AT
#### THE INFORMATION CENTRE,
#### TOWN HALL, FARNWORTH.

A. & S. Ltd., Printers, Farnworth

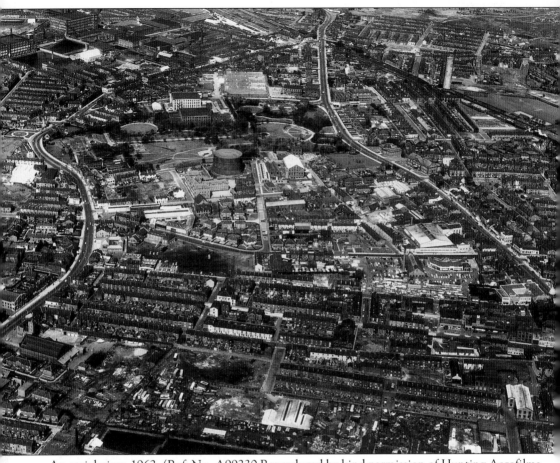

An aerial view, 1962. (Ref. No. A99230 Reproduced by kind permission of Hunting Aerofilms, Gate Studios, Station Road, Borehamwood, Herts. WD6 1EJ)

Be Just and Fear Not
Farnworth's Motto

*This is a motto good to take in life's stern battle, and to make
Life honourable, for truth's own sake, 'Be just and fear not!'*

*A motto good for man or town, to break all fraud and evil down,
And lead us on to fair renown, 'Be just and fear not!'*

*It hath the ring of hope and cheer, when clouds are gathering dark and drear,
Let danger distant seem or near, 'Be just and fear not!'*

*It gives the brave man confidence, and knows no horror of suspense,
Will do and dare the consequence, 'Be just and fear not!'*

*This is no coward's motto, men alone may claim it, who again
Rise up from grief and failure, then 'Be just and fear not!'*

By William Cryer, Farnworth poet, 1902 (in *Lays after Labour*, Blackshaw, 1913)